IMAGES
of America

CLEARWATER

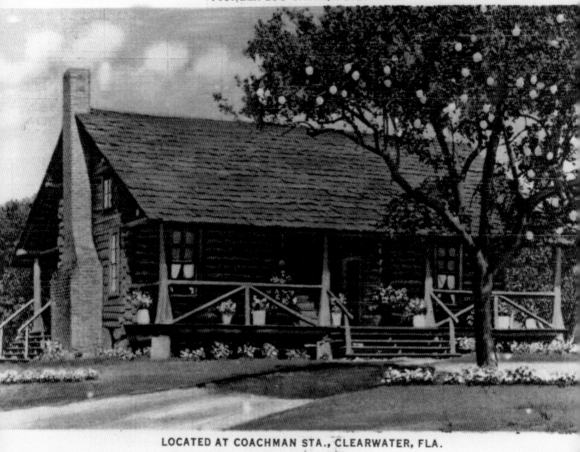

PIONEER LOG CABIN, BUILT 1851

LOCATED AT COACHMAN STA., CLEARWATER, FLA.

Built in 1851, this restored pioneer log cabin is located at Coachman Station. It has the standard characteristics of many "Florida Cracker" homes in that day—a fireplace, large front porch, and a loft for extra space. (Courtesy of HCPL.)

IMAGES
of America

CLEARWATER

Lisa Coleman

ARCADIA
PUBLISHING

Published by Arcadia Publishing
Charleston SC, Chicago IL, Portsmouth NH, San Francisco CA

Printed in the United States of America

Library of Congress Catalog Card Number: 2002104051

For all general information contact Arcadia Publishing at:
Telephone 843-853-2070
Fax 843-853-0044
E-mail sales@arcadiapublishing.com
For customer service and orders:
Toll-Free 1-888-313-2665

Visit us on the Internet at www.arcadiapublishing.com

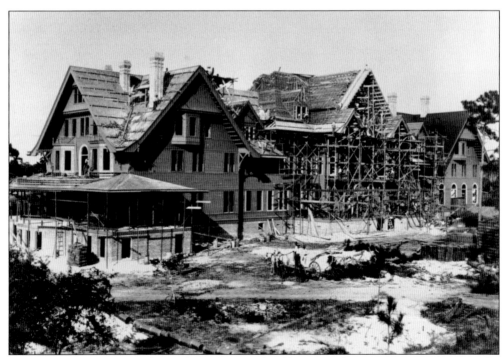

This image shows the south facade of the Hotel Belleview under construction in 1896. The hotel was later renamed the Belleview Biltmore Hotel and was visited by many wealthy winter guests. After the turn of the century, the hotel was painted white and was known as the "White Queen of the Gulf." (Courtesy of HCPL.)

CONTENTS

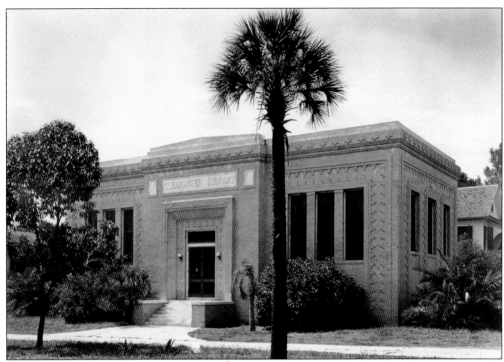

The Clearwater Public Library is shown here as it appeared on June 19, 1925, when it was located at 107 North Osceola Avenue. As of the printing of this book, the current library is being demolished within the next few months for a new 90,000-square-foot state-of-the-art facility. (Courtesy of HCPL.)

ACKNOWLEDGMENTS

I would like to thank everyone who has given me the courage to pursue my dreams of being a writer—most of all, my family. My children, Jerry, Alecia, and Kaela, have given up quality time with me on several weekends and my husband, Jerry, has given me several hours to work on, proofread, and edit this book. I want to give my sincere appreciation to my friends John Gravat and Milta Vega who picked up my children and took them to their designated functions when I was unable to do so. A special thank you to Melissa Tennant and Ed Santilli at the Hillsborough County Public Library for all of the patience and kindness shown to me while working on this project. Photos were taken from the Burgert Brothers Collection at the Hillsborough County Public Library (HCPL), the Clearwater Public Library (CPL) archives, Clearwater Historical Society (CHS) archives, and the Florida State (FSA) archives. Thank you for the use of all of these photos.

INTRODUCTION

Imagine a sunny day along a secluded undeveloped land where the only sound comes from the crash of waves upon the shore and birds singing in harmony with each other. This was Clear Water Harbor in the early 1800s before the railroad tycoons, land developers, and utility magnates transformed this glorious land into what is now known as one of the most popular vacation spots in the United States.

The Seminole Indians had migrated to Florida from Georgia and the Carolinas, claiming Florida as their new home. Prior to the second Seminole War in 1835, Clear Water Harbor became a territory of the United States. In 1841 Fort Harrison, named after William Henry Harrison, was created as a refuge for wounded soldiers. It was located on a bluff where the water ran pure. As the Seminole War came to an end in 1842, the fort was disbanded and the location is now distinguished with a plaque on Druid Road in the Harbor Oaks subdivision.

In the mid-1830s, the first white settler on the Pinellas Peninsula was Dr. Odet Philippe (Count Odet Philippe, great nephew of King Louis XVI). He was a surgeon in the French Navy under Napoleon. Dr. Philippe is remembered in Clearwater as being a great surgeon and the one individual who introduced the theory of planting citrus trees in a row.

Many individuals and families helped to transform Clearwater into a community they could call home. In 1842, after the second Seminole Indian War, the U.S. government passed the Armed Occupation Act, which gave 160 acres of land to any head of family or single man over the age of 18 who would bear arms and live on the land for at least 5 years. During these 5 years, the landowner was required to cultivate at least 5 of those 160 acres. James Stevens, "the Father of Clearwater," submitted the first of more than 1,300 claims for land. Among the other families who came to Clearwater were the McMullens, Coachmans, Plants, Gilcrists, and Kilgores. These settlers found beautiful beaches, uninhabited areas, and a sight that some believed existed only in their dreams. However, the crystal clear water that flowed in the Gulf of Mexico was not all they found; they also found the area's longtime residents, the Indians.

By 1859, a man by the name of David B. Turner had created the first post office in Clearwater. During the Civil War, the post office was suspended. It was reinstated in 1865 with Robert J. Whitehurst as postmaster. In 1873 Clearwater's first newspaper, *The Clear Water Times* was created by Rev. C.S. Reynolds. Reynolds was a minister from New York and had founded the *Tampa Herald* in 1854.

Clear Water Harbor was incorporated in 1891. In 1895 Clearwater became one word, and in 1906 "Harbor" was dropped. Clearwater is the county seat of Pinellas County, but it was a part of Hillsborough County until 1911. Citizens of Clearwater and St. Petersburg fought Tampa for their own government, because they were paying county taxes but not receiving any of the benefits. Tampa, the seat of Hillsborough County, was getting new roads and a large percentage of the tax dollars was being put into new government facilities. However, receiving its independence from Hillsborough County did not solve all of the problems in Clearwater

and the surrounding towns. Clearwater and St. Petersburg began their own feud over who was going to be the county seat. Clearwater gained control and built a new wooden structure almost overnight, costing $3,700. This ensured their position as the county seat.

As progress continued, another major event occurred in 1888 when the Orange Belt Railroad, a narrow-gauge rail system, guided the first train into St. Petersburg. The tracks ran from Sanford to St. Petersburg and linked Clearwater with the outside world. Peter Demens, using Russian architecture, developed this rail system. In 1895, the Orange Belt Railroad became part of Henry B. Plant's Railroad. The name changed to the Stanford & St. Petersburg Railroad and a standard gauge track was installed in 1897. In 1902, Atlantic Coast Line Railway obtained the old Orange Belt. The Atlantic Coast Line Railway system eventually merged with the Seaboard Air Line Railway and then into the Seaboard Coast Line.

Henry B. Plant continued his legacy with the building of the Belleview Biltmore Hotel. Plant obtained 625 acres in Belleair because the taxes in Clearwater were too high. He chose a bluff overlooking the Gulf. Henry died before the completion of the hotel, but his son, Morton F. Plant, saw the project through completion. This remarkable hotel became known as the "White Queen of the Gulf." It is the largest wooden-structure hotel in the world and is listed on the National Register of Historic Places.

Following in his father's footsteps, Morton F. Plant was a great contributor to Clearwater's success. He not only finished the Belleview Biltmore, but he also made a true name for himself by funding the majority of the money to build the first hospital in Clearwater. Plant had agreed to put up a $100,000 endowment; however, the community had to raise the remaining $20,000. The Morton F. Plant hospital was completed in 1915.

As the population of Clearwater grew and the pioneer settlers began having children, these native Floridians became known as "Florida Crackers" because of the distinguishing sound a whip made when it was used on livestock to transport supplies and produce by wagon. Clearwater, like so many other towns in Central Florida, relied on agriculture as a means of survival. Tourism and commercialism did not take hold until the late 1800s.

Today, Clearwater is dependent upon good weather for economic success. While fishing and agriculture are still major industries, tourism is the main pipeline that keeps Clearwater thriving as an independent city.

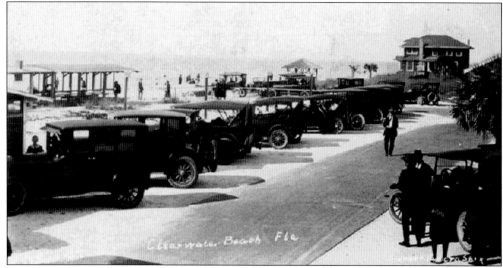

This view of Clearwater Beach looks north near the Clearwater Beach Pavilion and the Sunset Camera Shop around the late 1920s or early 1930s. (Courtesy of CPL.)

One

LATE 1800s

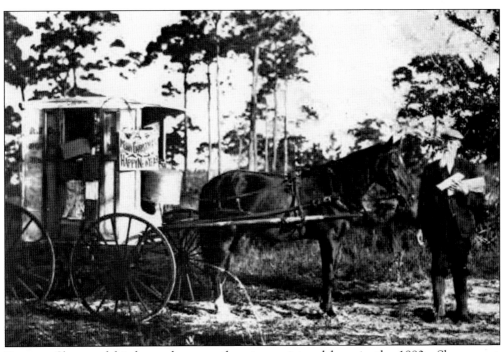

Postman Shaw and his horse-drawn mail cart are pictured here in the 1880s. Shaw was a Rural Federal Delivery postman whose route included South Clearwater and the Belleair area. (Courtesy of FSA.)

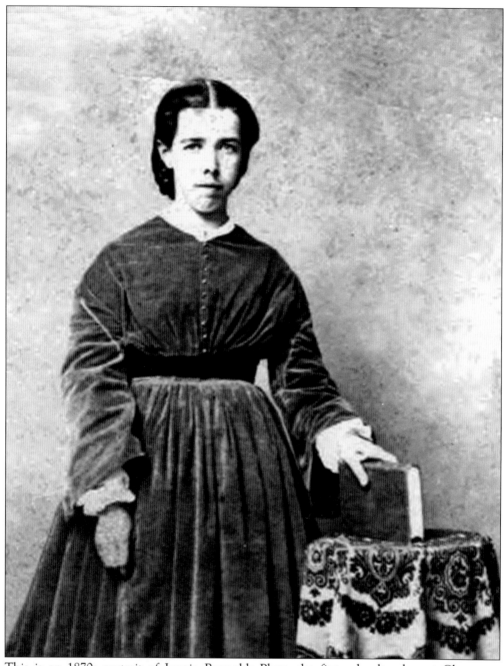

This is an 1870s portrait of Jennie Reynolds Plum, the first schoolteacher at Clearwater Elementary School. (Courtesy of FSA.)

Looking north from the corner of Cleveland Street and Osceola Avenue, this image was taken near the "Twin Palms," a local landmark. This photograph is dated 1890. (Courtesy of CHS.)

The 1880s photograph below shows the Stevenson Creek Bridge looking north, connecting Clearwater to Dunedin. (Courtesy of CHS.)

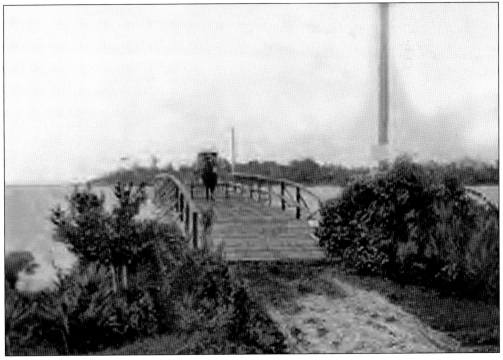

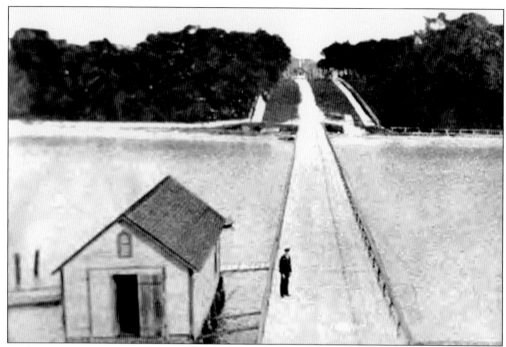

Looking east up Cleveland Street from the Public Pavilion, this photograph was taken in the 1880s. The pier in the picture served the supply boats that also carried the mail from Cedar Key. It was replaced in 1902 with a newer pier. (Courtesy of CHS.)

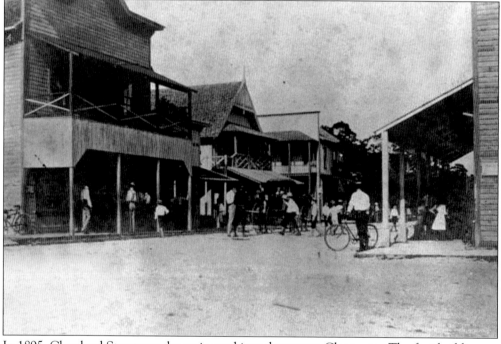

In 1895, Cleveland Street was the main road into downtown Clearwater. The first building on the left is the Bank of Clearwater, the third on the left is Rehbaum's Hardware Store, and the building on the right is the Coachman Building. (Courtesy of FSA.)

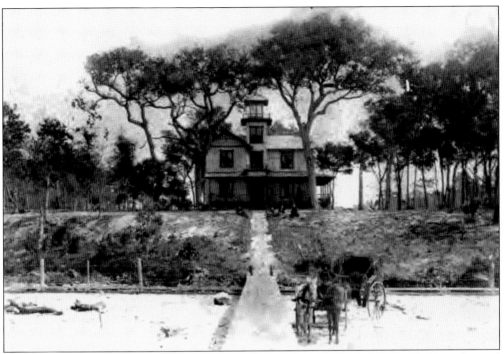

J.R. Brumby's home near Clearwater Harbor is visible in this photo from 1886. It was located on the bluff between Dunedin and Clearwater. Note the horse and buggy in the foreground. (Courtesy of FSA.)

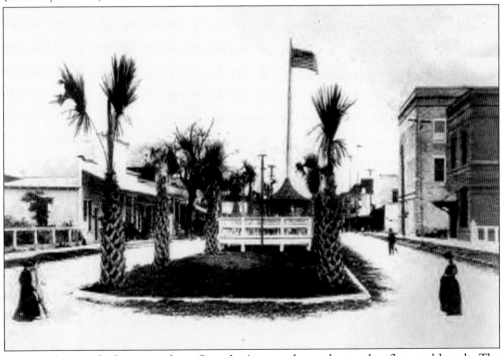

Cleveland Street looking east from Osceola Avenue shows the gazebo, flag, and bench. The Whitcomb Building is second on the right, c. 1890. (Courtesy of CHS.)

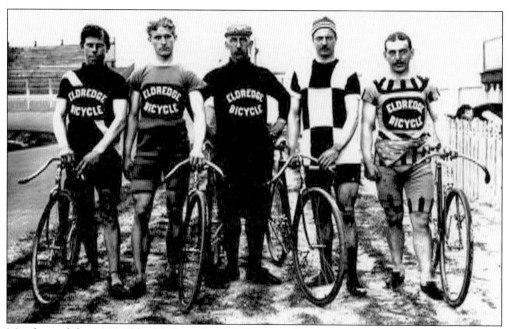

Members of the 1898 Eldredge Bicycle Club from England posed at the International Bicycle Track. (Courtesy of CPL.)

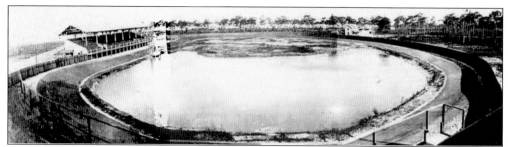

This 1898 photograph shows the International Wooden Bicycle Track, which was located on the 12th, 13th, and 14th holes of the Belleview Biltmore Hotel Golf Course. Championship bicycle racing teams held competitions here in front of hundreds of local fans. Within a few years, the public lost interest, the track fell into disrepair, and it was eventually dismantled. (Courtesy of CPL.)

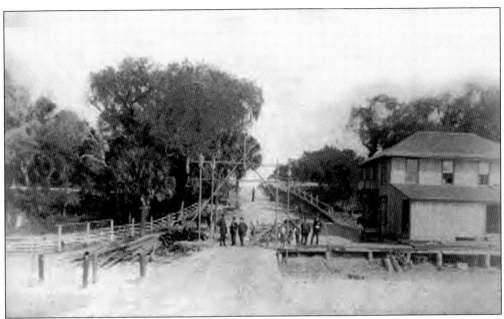

This view looks up Cleveland Street to the east in 1886. (Courtesy of CHS.)

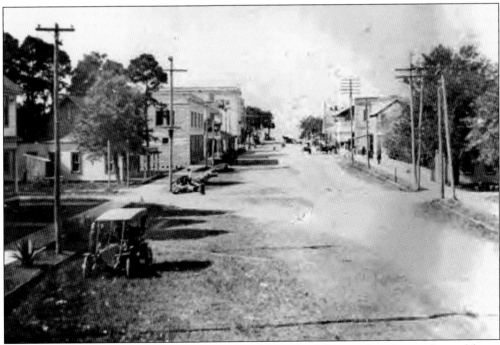

This 1890s photograph shows the south side of Cleveland Street after the gazebo and horse troughs were removed, which made Cleveland Street look wider. (Courtesy of CHS.)

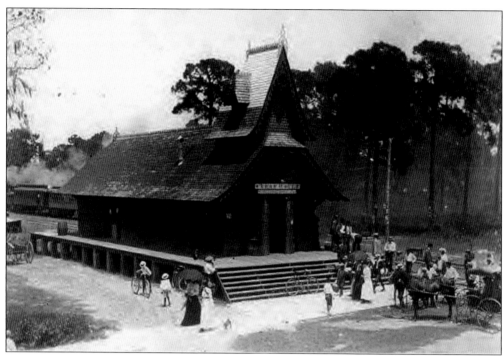

Pictured here is the Orange Belt Railroad Station on Cleveland Street as it was in 1898. This was the first railroad in Clearwater and was constructed of a narrow gauge rail system designed by a Russian engineer named Peter A. Demens. (Courtesy of CHS.)

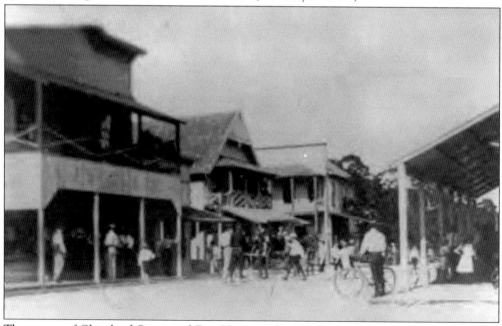

The corner of Cleveland Street and Fort Harrison Avenue shows the Bank of Clearwater and Bowker Fertilizer Store on the left and the Old Coachman General Store on the right. The General Store was replaced by the Coachman Building. The exact date of this photograph is unknown, but it was taken between 1890 and 1900. (Courtesy of CHS.)

Two

1900s–1910s

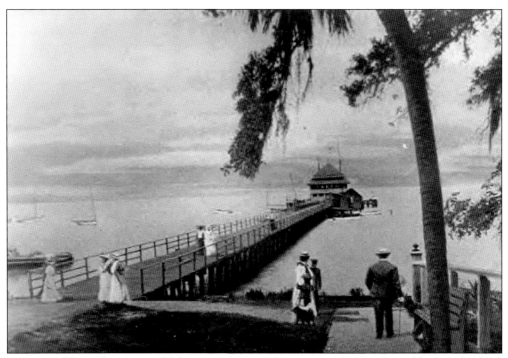

Dances, public gatherings, and fishing were among the activities held at the public boat landing, pier, and pavilion, shown here c. 1902. It was replaced by the Memorial Causeway in 1927. (Courtesy of CHS.)

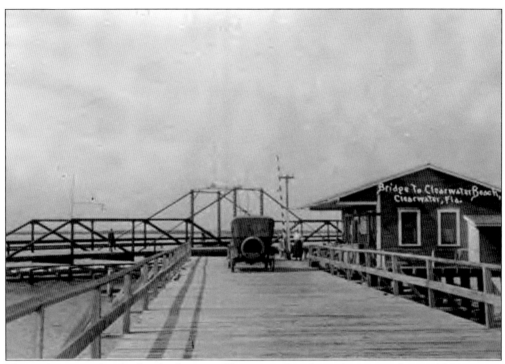

The rickety wooden bridge leading to Clearwater Beach is shown in this *c.* 1900 image. (Courtesy of FSA.)

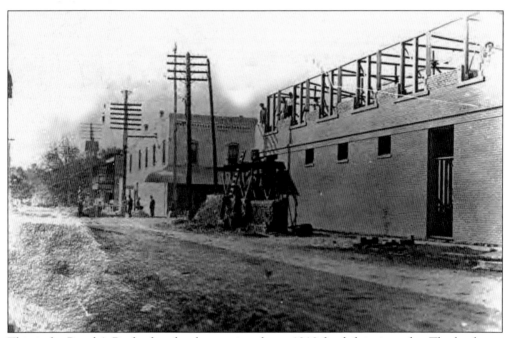

This is the People's Bank after the devastation that a 1910 fire left in its wake. The bank was located on Fort Harrison Avenue. (Courtesy of FSA.)

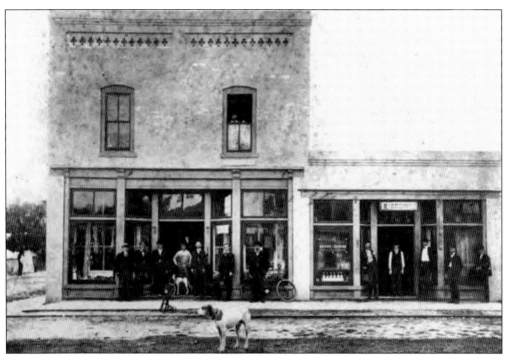

This single-story building on the right was home to J.W. Matghett's Drug Store on Cleveland Street in 1900. (Courtesy of FSA.)

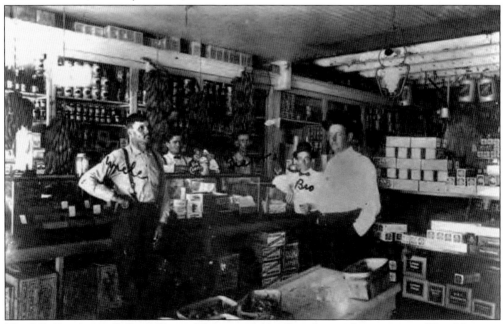

The S.S. Coachman & Son's General Store was located on the southeast corner of Fort Harrison Avenue and Cleveland Street in 1902. This store was the largest in town, and Coachman, a native of Georgia who settled in Clearwater in 1886, ran it for 20 years. Coachman was one of the pioneer leaders who fought to separate Pinellas County from Hillsborough County. (Courtesy of FSA.)

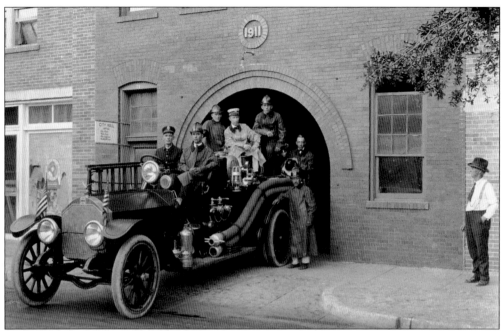

In 1915 firemen gather around a light-duty pumper in front of the fire station and City Hall building located on North Fort Harrison. Although the firemen were volunteers, they were paid $7 per fire. The man in the white coat was fire chief Ora Hart. (Courtesy of HCPL.)

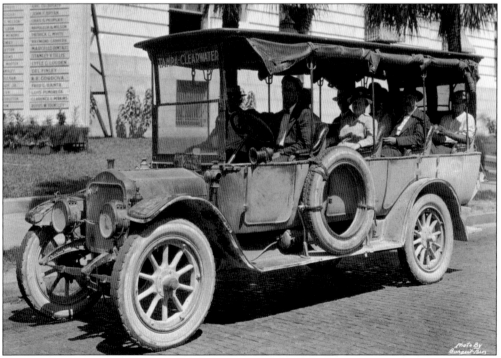

The Tampa-Clearwater bus carries passengers through Clearwater on a sunny day in October 1919. (Courtesy of HCPL.)

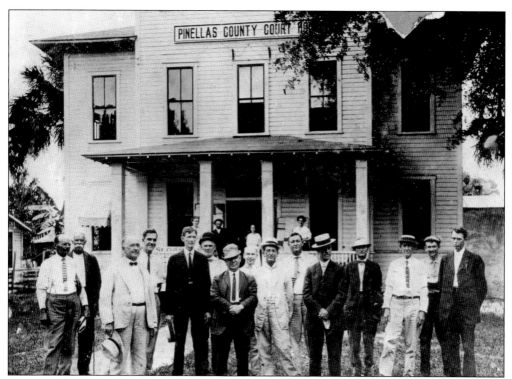

A group of important dignitaries and the first public officials of Pinellas County stand in front of the newly built Pinellas County Courthouse on South Fort Harrison Avenue in 1912. They are left unidentified due to inconsistent historical documents. (Courtesy of HCPL.)

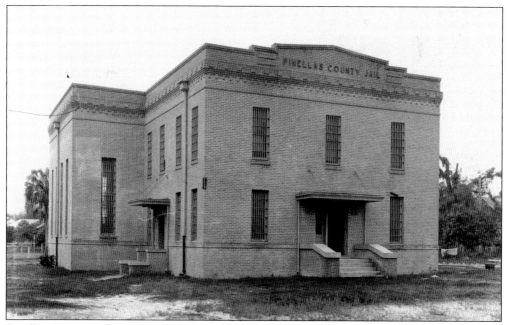

Pinellas County Jail stood at the corner of Markley Street and Palm Avenue in 1919. (Courtesy of HCPL.)

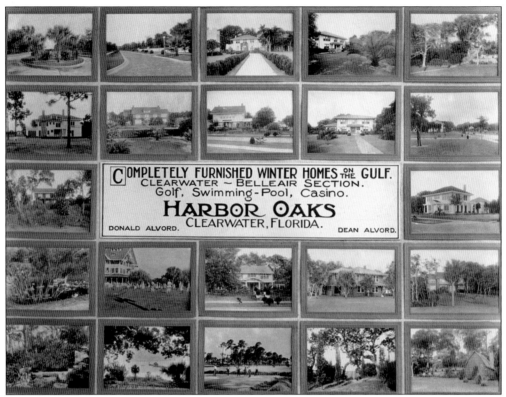

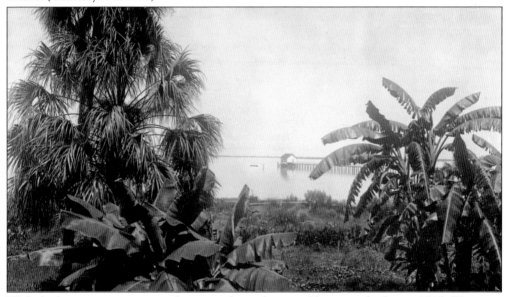

This is a 1919 advertising display of furnished homes located in the prestigious community of Harbor Oaks Subdivision. This subdivision encouraged northern residents, "Snow Birds," to enjoy the warmth of Florida during those brutal sub-zero temperatures they experienced in the winter. (Courtesy of HCPL.)

With the banana trees as cover, the pier is shown here on Clearwater harbor in 1915. (Courtesy of HCPL.)

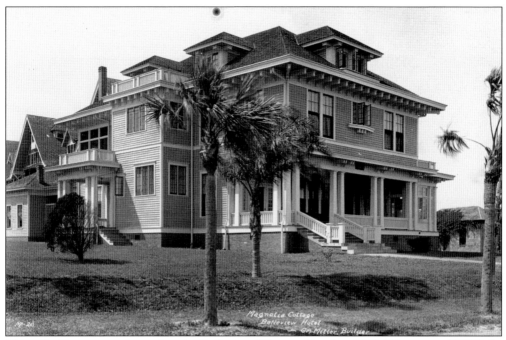

Magnolia Cottage was located at the Belleview Biltmore Hotel in 1919. (Courtesy of HCPL.)

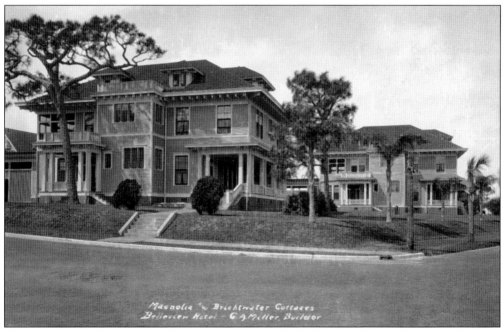

The Magnolia and Brightwater Cottages, located at the Belleview Biltmore Hotel, are shown in 1919. (Courtesy of HCPL.)

This is the front view of the swimming pool building at the Belleview Biltmore Hotel as it appeared in 1919. (Courtesy of HCPL.)

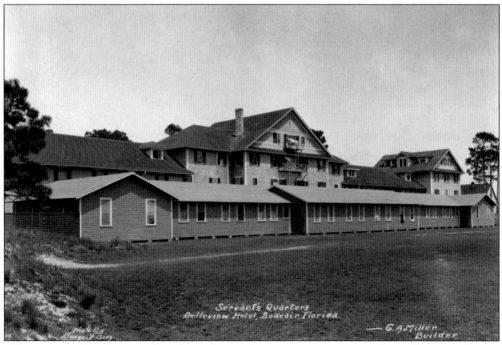

Taken on March 10, 1919, this photo shows the servants' quarters at the Belleview Biltmore Hotel. (Courtesy of HCPL.)

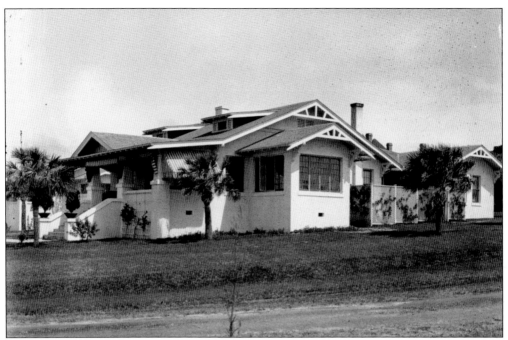

The Bungalow at the Belleview Biltmore Hotel is shown in 1919. (Courtesy of HCPL.)

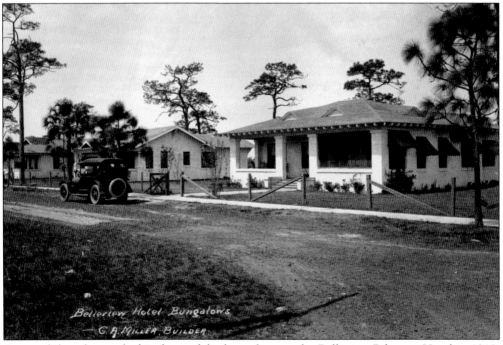

Automobiles often parked in front of the bungalows at the Belleview Biltmore Hotel in 1919. (Courtesy of HCPL.)

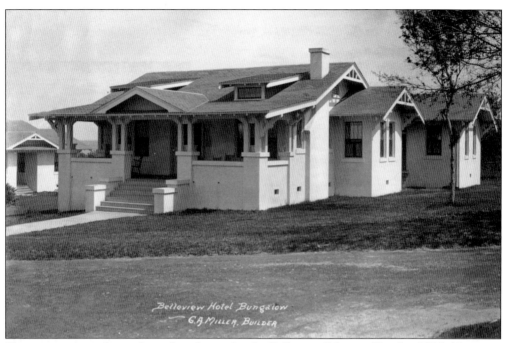

Shown is just one of many bungalows located at the Belleview Biltmore Hotel in 1919. (Courtesy of HCPL.)

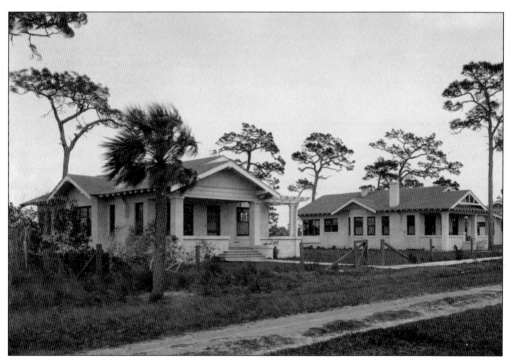

The Belleview Biltmore Hotel's bungalows were located down a secluded dirt road in 1919. (Courtesy of HCPL.)

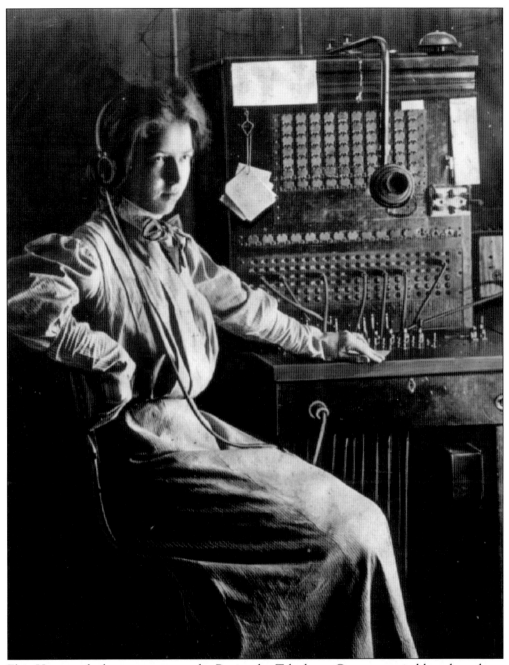

Elsie Hart, a telephone operator at the Peninsular Telephone Company switchboard, works at her station, c. 1904. (Courtesy of HCPL.)

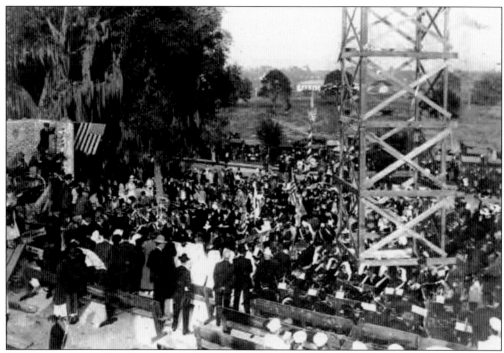

Six years after Clearwater became the county seat, it finally had a permanent building. This photograph captures the cornerstone-placing ceremony for the second Pinellas County Courthouse in 1918. (Courtesy of FSA.)

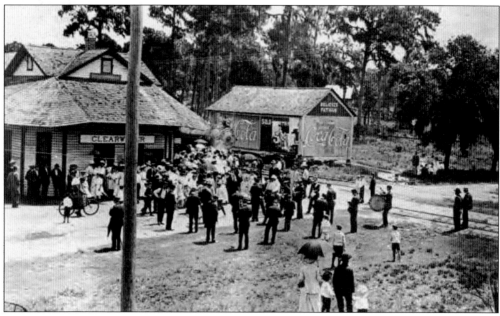

The Clearwater Concert Band played at the railroad depot in honor of the arrival of an unidentified dignitary on June 16, 1910. (Courtesy of FSA.)

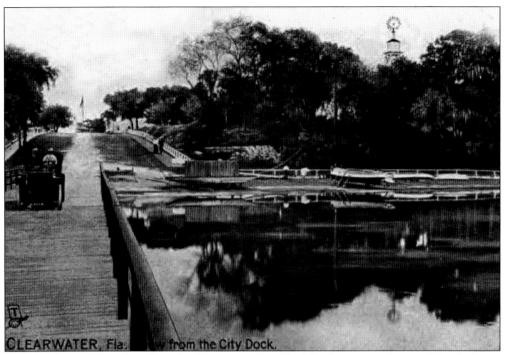

This 1910 image was taken from the Clearwater City Dock looking towards town. The dock was at the foot of Cleveland Street. (Courtesy of FSA.)

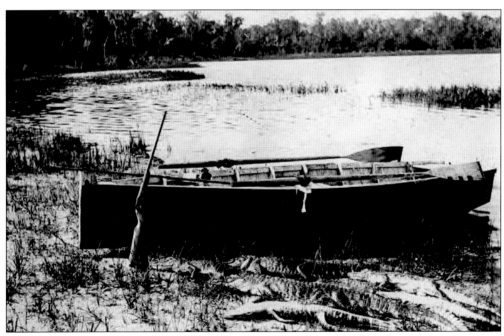

Harry Hewitt's recent kill rests next to his alligator hunting boat and equipment, c. 1917. (Courtesy of FSA.)

A 1912 view of Cleveland Street looking east includes the Bank of Clearwater and Cash Dry Goods Store. (Courtesy of HCPL.)

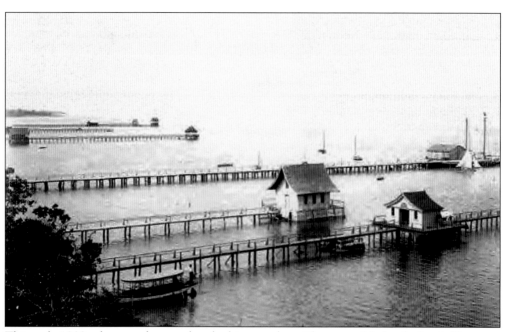

This early 1900s photograph was taken looking south at Clearwater Harbor by Louis Ducros, a pioneer photographer in Clearwater. (Courtesy of CHS.)

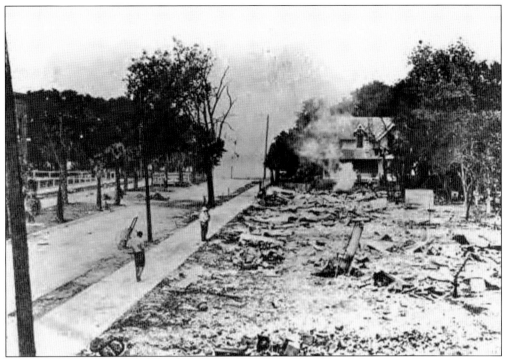

The June 24, 1910 fire destroyed most of the buildings on the north side of Cleveland Street. Note the smoldering debris in the background near the only home that remained unharmed by the blaze. Soon after this fire, a volunteer fire department was created and the City of Clearwater purchased the needed fire equipment in 1914. (Courtesy of FSA.)

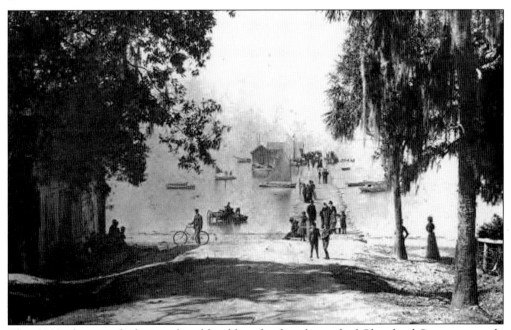

This 1910 photograph depicts the old public wharf at the end of Cleveland Street as people gather for social activities. (Courtesy of FSA.)

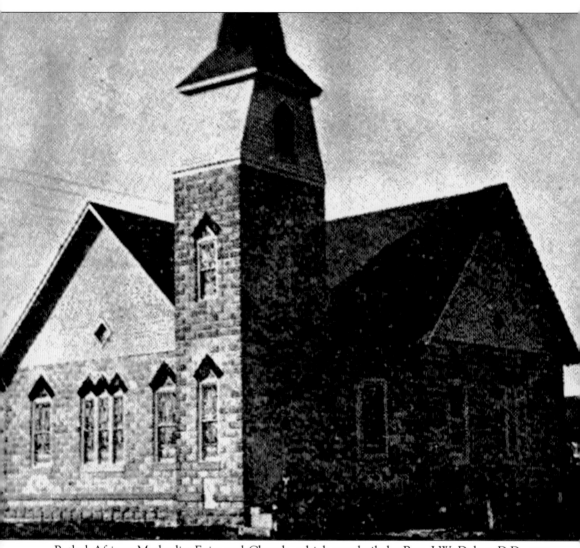

Bethel African Methodist Episcopal Church, which was built by Rev. J.W. Dukes, D.D., was photographed in 1915. (Courtesy of FSA.)

Three

1920s

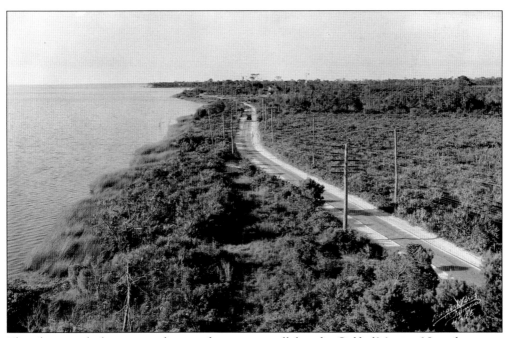

This photograph shows a two-lane road running parallel to the Gulf of Mexico. Note the power lines placed along the road's edge, c. 1924. (Courtesy of HCPL.)

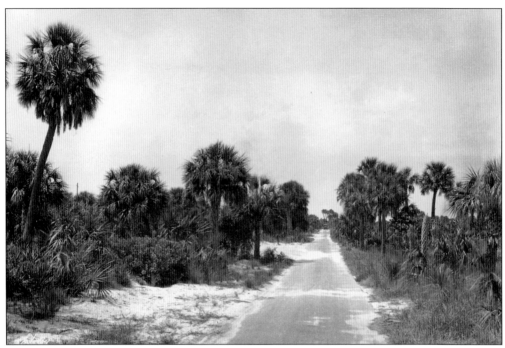

Newly paved Mandalay Road on Clearwater Beach was captured in 1921. This secluded, palmetto-lined road gave tourists access to the original beach pavilion. (Courtesy of HCPL.)

In 1921, Clearwater possessed characteristics that much of Florida had in this decade. Fields, swamps, and undeveloped land were abundant. (Courtesy of HCPL.)

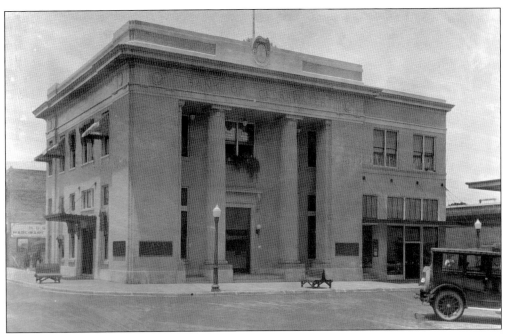

This photograph, taken in June 1922, shows the Bank of Clearwater on the corner of Cleveland Street. (Courtesy of HCPL.)

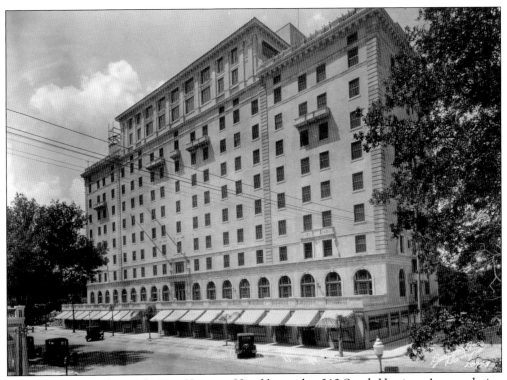

Tourists found comfort at the Fort Harrison Hotel located at 212 South Harrison Avenue during the Roaring Twenties. (Courtesy of HCPL.)

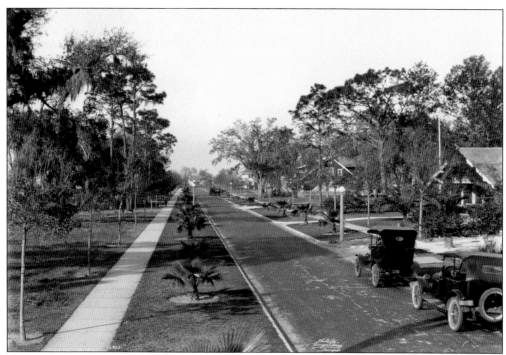

Drivers parked their cars along the curb of Druid Road, a residential area, in 1921. (Courtesy of HCPL.)

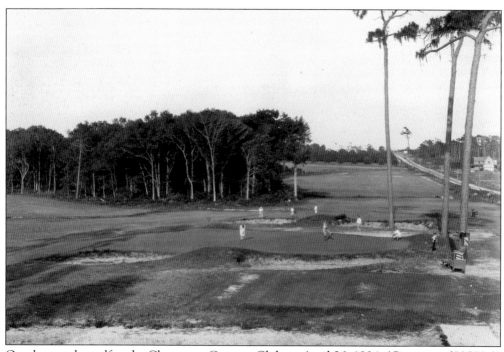

Gentlemen play golf at the Clearwater Country Club on April 26, 1924. (Courtesy of HCPL.)

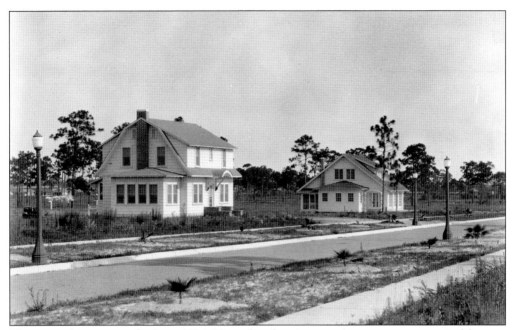

These new homes were built in 1924. Note the electric street lamps in a symmetrical line on either side of the street. (Courtesy of HCPL.)

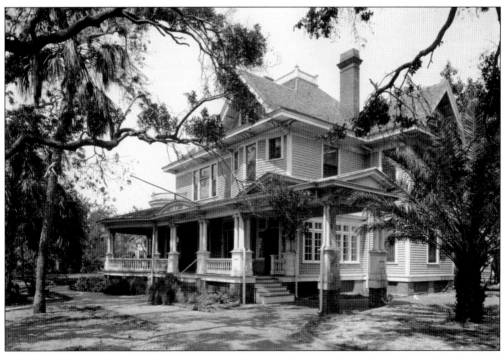

A 1922 photograph depicts the two-story Community Tourist Building. (Courtesy of HCPL.)

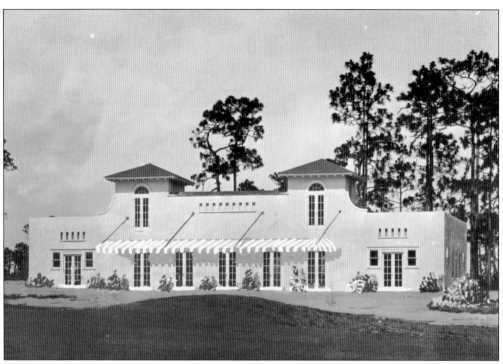

Clearwater Country Club was located on Betty Lane in 1922. (Courtesy of HCPL.)

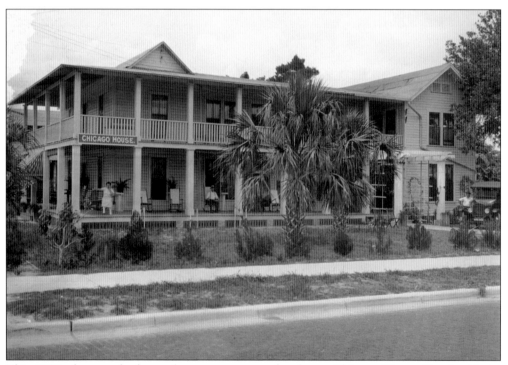

This 1922 photograph shows the two-story, wooden-frame Chicago House Hotel with its wraparound porch and rocking chairs. (Courtesy of HCPL.)

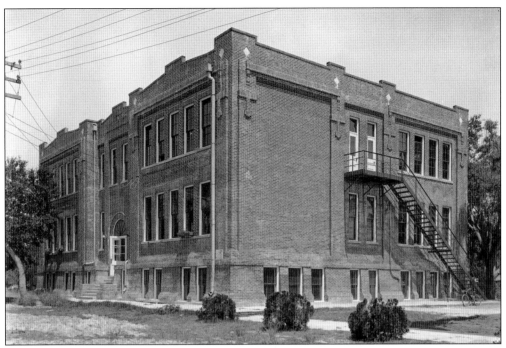

This 1922 image shows the South Ward School on the northwest corner of Fort Harrison Avenue and Pine Street. It was built in 1906. (Courtesy of HCPL.)

This building was adjacent to South Ward School on the Northwest corner of Fort Harrison and Pine Street in 1922. (Courtesy of HCPL.)

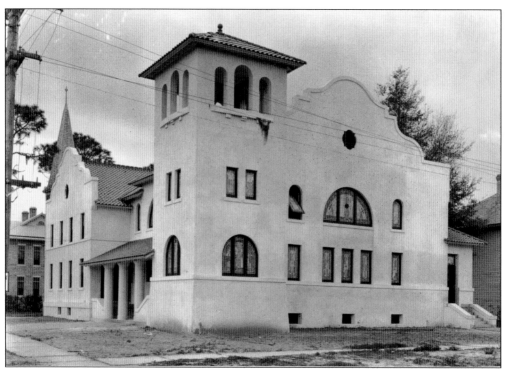

This is a side view of the First Methodist Church on Fort Harrison Avenue South in 1921. (Courtesy of HCPL.)

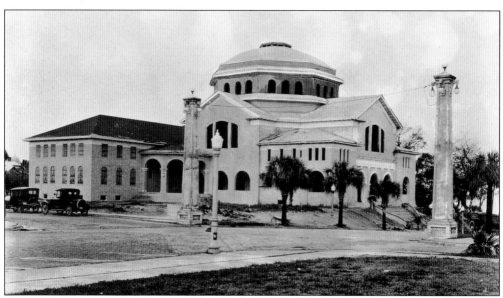

On the southwest corner of Cleveland Street and Osceola Avenue stood the Calvary Baptist Church. This photo was taken in 1924 while it was still under construction. The church was organized on March 25, 1866, by Rev. C.S. Reynolds with the name "Midway Baptist Church." It was renamed Clearwater Baptist in 1878 and obtained its current name in 1923. (Courtesy of HCPL.)

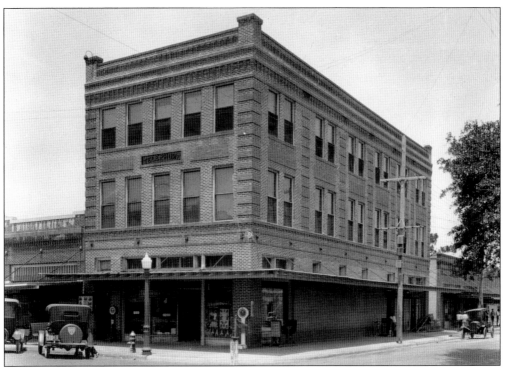

The Peninsular Telephone Company building, located on the Northwest corner of Garden Avenue and Cleveland Street, is pictured in 1922. (Courtesy of HCPL.)

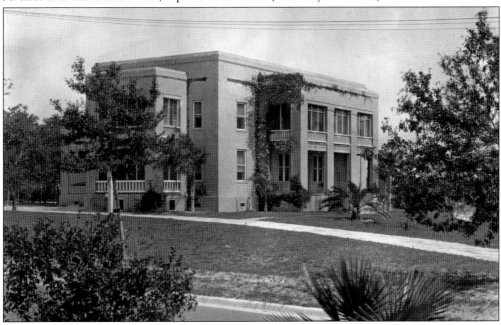

This is the Morton F. Plant Hospital at 301 Jefferson Street in 1922. Plant was the son of railroad baron Henry B. Plant, who brought the railroad to Tampa Bay in the 1880s. This hospital was built in 1914 after Plant offered $100,000 to the project, providing that private citizens would raise $20,000. (Courtesy of HCPL.)

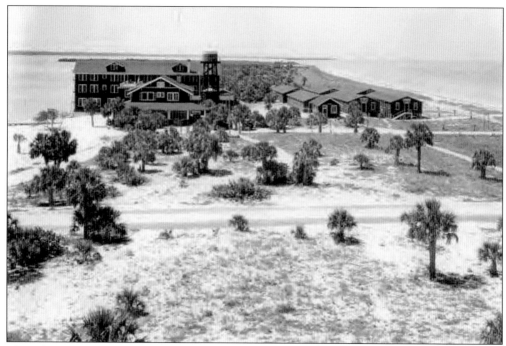

The Clearwater Beach Hotel, built in 1918, was photographed on May 26, 1921. This image shows the Southern College classrooms and barracks on the right. The school was eventually moved to Lakeland and was renamed Florida Southern College. (Courtesy of FSA.)

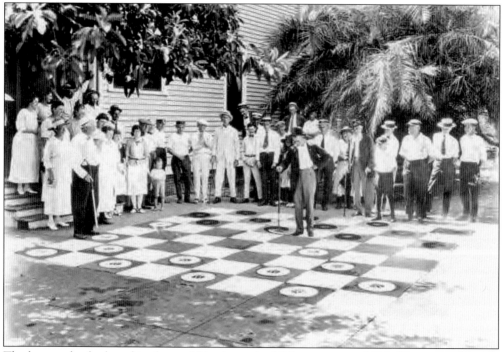

The largest checkerboard in the world is pictured—16 feet square, c. 1922. (Courtesy of FSA.)

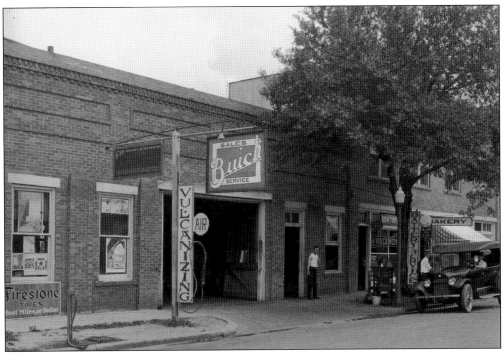

This Buick dealership in 1922 sold Firestone tires and advertised vulcanizing and battery service. Customers could visit the bakery next door while their cars were being serviced. (Courtesy of HCPL.)

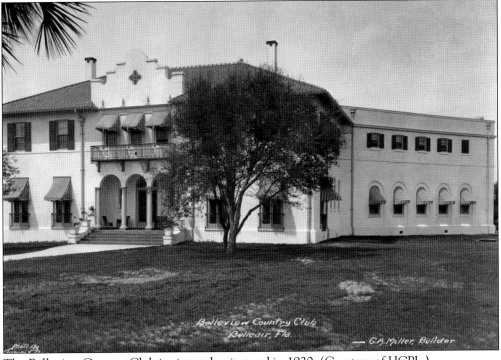

The Belleview Country Club is pictured as it stood in 1920. (Courtesy of HCPL.)

In 1925, this land was cleared for the main boulevard, the Ben T. Davis Causeway. Upon completion, Clearwater residents could drive straight across Tampa Bay to visit Tampa for a 50¢ round-trip toll. (Courtesy of HCPL.)

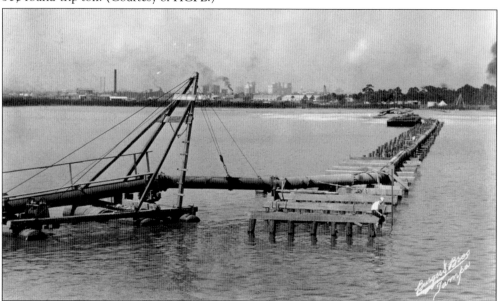

With Tampa in the distance, builders construct the Ben T. Davis Causeway, c. 1925. During World War II, some politicians took over the Davis Causeway to free it from tolls. When the causeway was widened, the name was changed to the Courtney Campbell Parkway in honor of the man responsible for the new improvements, board member Courtney Campbell. (Courtesy of HCPL.)

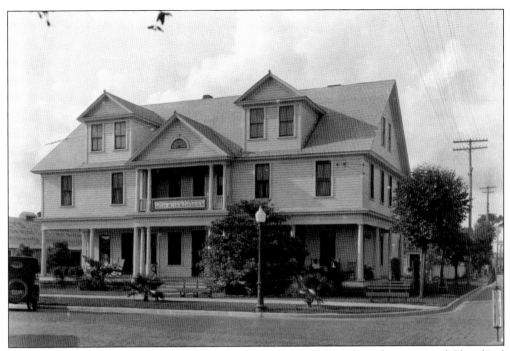

This 1922 image captures the Phoenix Hotel, which was located on the corner of Cleveland Street and Garden Avenue. It was a popular spot for Sunday dinner and its wraparound porch was a popular spot for guests to relax. The hotel was torn down in the early 1960s. (Courtesy of HCPL.)

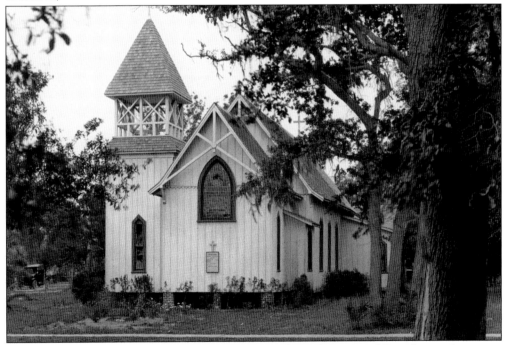

Built in 1883 and located on the northwest corner of Bay Avenue and Pine Street, Ascension Episcopal Church is pictured here in 1922. (Courtesy of HCPL.)

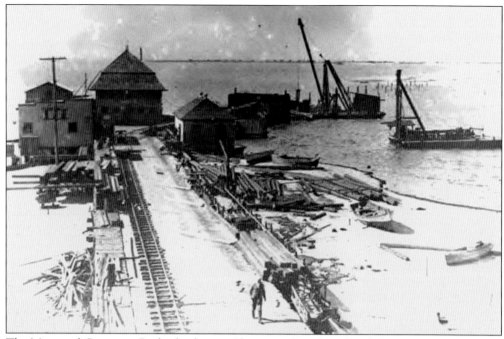

The Memorial Causeway Bridge leading to Clearwater Beach replaced the previous public boat landing, pier, and pavilion. This causeway was built as a memorial to the World War I heroes and veterans in 1924. (Courtesy of FSA.)

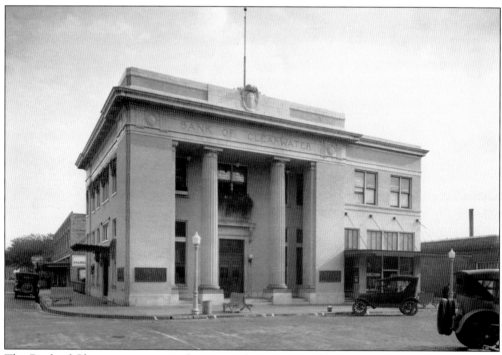

The Bank of Clearwater is pictured as it stood in 1924 on the northwest corner of Cleveland Street and Fort Harrison Avenue South. (Courtesy of HCPL.)

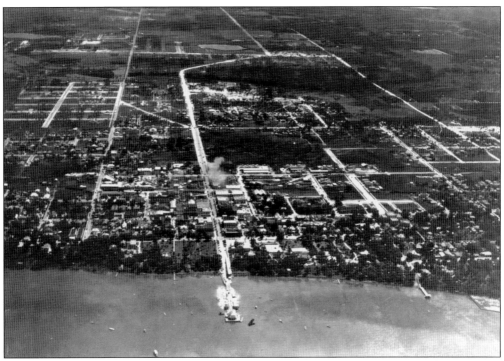

This aerial view of the Pinellas County peninsula focuses on Clearwater (Cleveland Street East, Route 60, and Old Tampa Bay). The photograph was taken on December 18, 1925. (Courtesy of HCPL.)

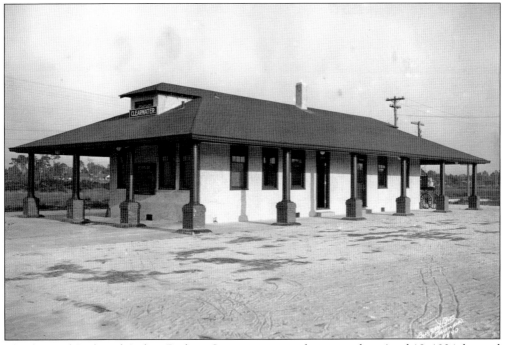

The deserted Seaboard Airline Railway Station is pictured as it stood on April 18, 1924, located on East Avenue South. (Courtesy of HCPL.)

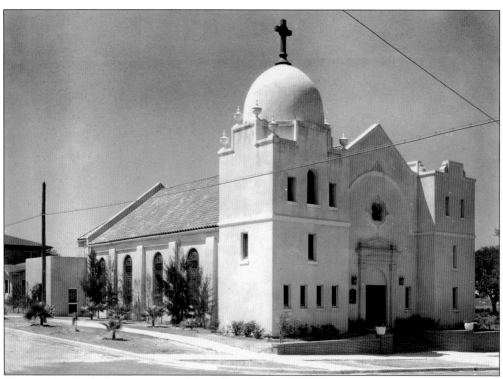

St. Cecilia's Catholic Church Building, located at 828 Jasmine Way, was photographed on April 19, 1928. (Courtesy of HCPL.)

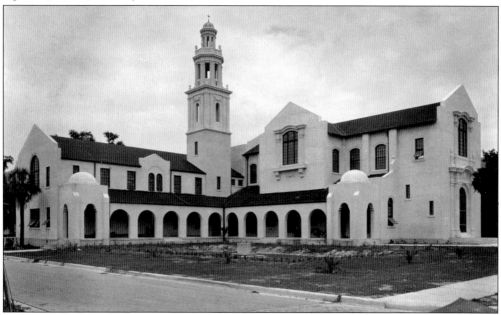

This photograph shows the newly completed Peace Memorial Presbyterian Church in 1921. This church was located at the corner of Fort Harrison Avenue South and Pierce Street. This Spanish-style stucco structure replaced the original wooden building, which was constructed in 1895. The church was organized in 1891 by Rev. Luther H. Wilson.(Courtesy of HCPL.)

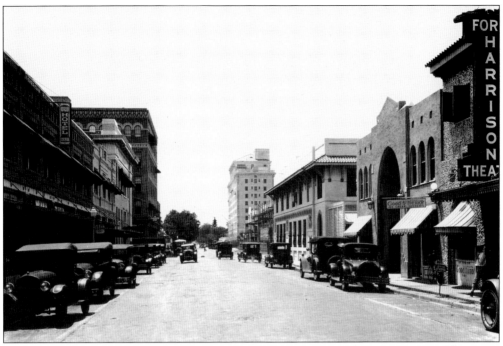

Looking north on North Fort Harrison Avenue as it was in 1926, the Fort Harrison Theater is seen on the right and the Borden Hotel is on the left. (Courtesy of HCPL.)

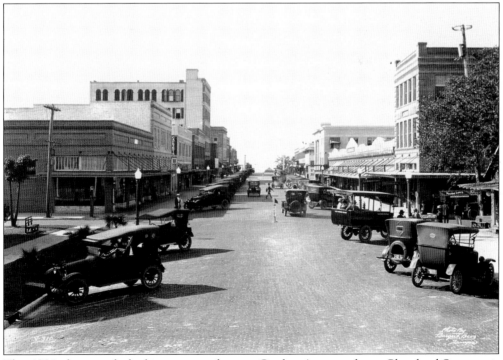

This 1921 photograph, looking westward across Garden Avenue, shows Cleveland Street as it looked in the early days of commercial growth. (Courtesy of HCPL.)

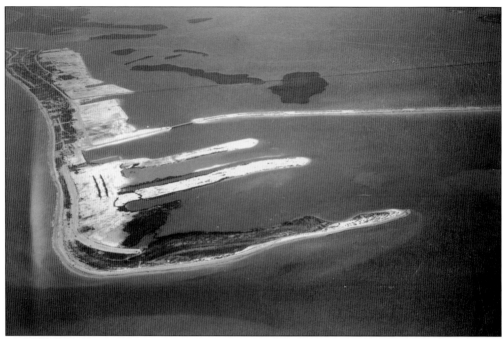

In 1928, Clearwater Beach was undeveloped. This aerial view depicts Clearwater Beach, its surrounding islands, and the causeway before commercialism. (Courtesy of HCPL.)

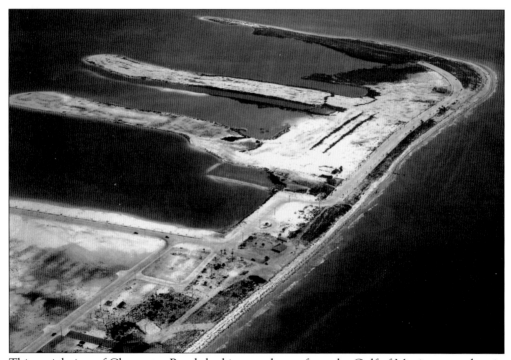

This aerial view of Clearwater Beach looking southwest from the Gulf of Mexico was taken in 1928. (Courtesy of HCPL.)

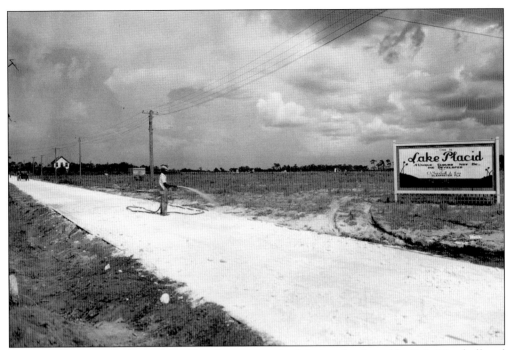

In 1925, this sign advertised Lake Placid as a new suburb being developed by E.A. Marshall and Sons. (Courtesy of HCPL.)

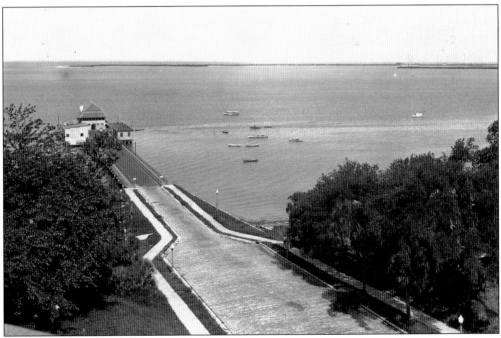

This view of Old Tampa Bay is looking east along Cleveland Street towards the pier in 1924. (Courtesy of HCPL.)

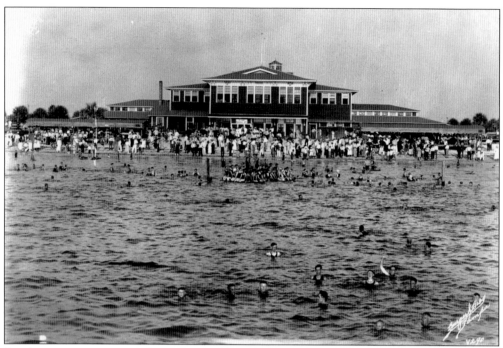

Beach-goers are enjoying themselves at the Clearwater Beach Pavilion in 1921. (Courtesy of HCPL.)

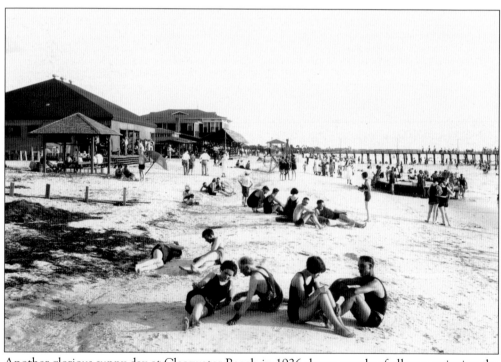

Another glorious sunny day at Clearwater Beach in 1926 shows people of all ages enjoying the sea breeze. (Courtesy of HCPL.)

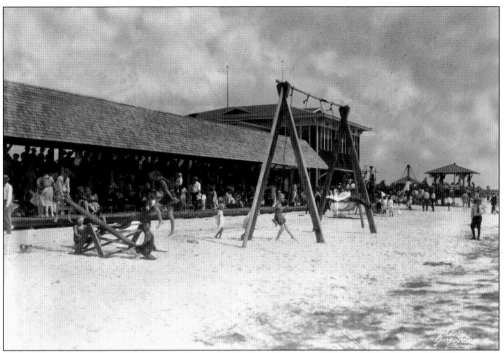

In 1922, Clearwater Beach was a place for the entire family to enjoy a beautiful day outdoors. (Courtesy of HCPL.)

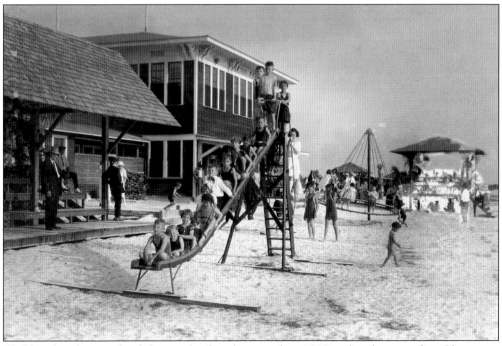

Children lined up on the slide pose for this photograph in 1922 at the playground on Clearwater Beach. (Courtesy of HCPL.)

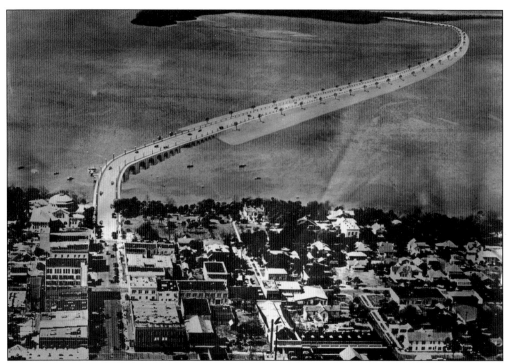

This 1925 aerial view of downtown Clearwater shows the proposed causeway, drawn in, connecting it with Clearwater Beach. (Courtesy of HCPL.)

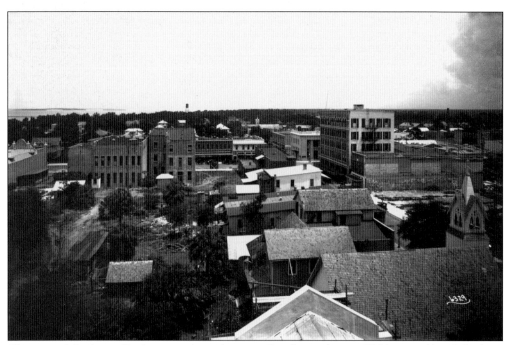

Clearwater's business district was taking shape in this shot, taken in 1921 at roof level, looking north along Fort Harrison Avenue. (Courtesy of HCPL.)

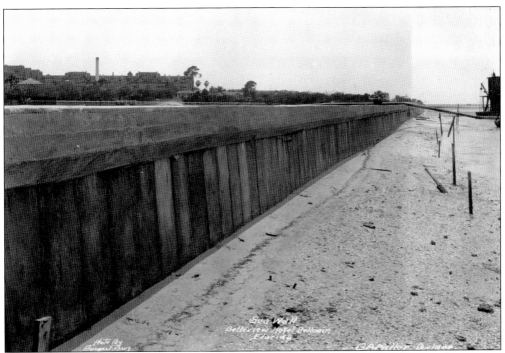

In 1920, this seawall kept the high tide from reaching the Belleview Biltmore Hotel grounds. (Courtesy of HCPL.)

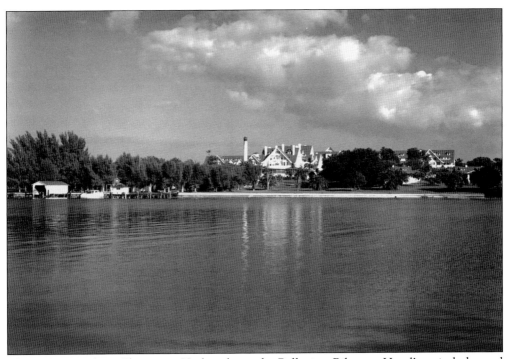

This 1924 view from Clearwater Harbor shows the Belleview Biltmore Hotel's main lodge and landscaped grounds. (Courtesy of HCPL.)

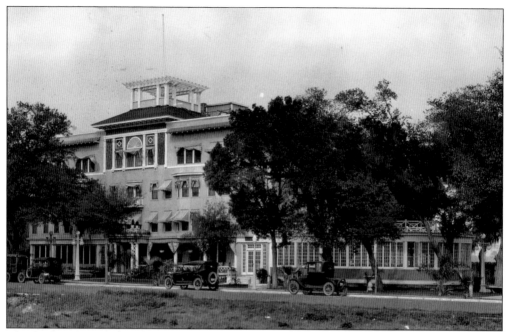

This is a view across the grounds of the Grey Moss Inn located at 201–231 Fort Harrison Avenue South in 1924. Built in 1889 as the Verona Inn, it was foreclosed and sold in 1903 for $1,200. It was owned by several families, until George Washburn bought it in 1926 and changed the name to Grey Moss Inn. (Courtesy of HCPL.)

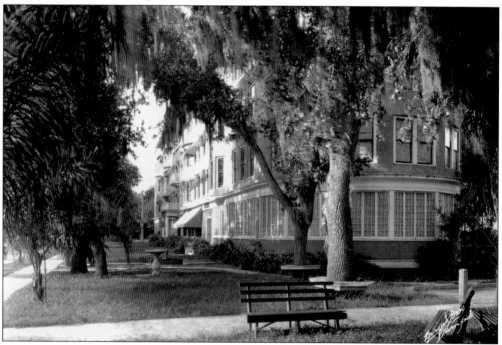

A side view of the Grey Moss Inn on Fort Harrison Avenue is seen in 1925. The inn was sold in 1933 to the John Welch family; they owned it for the next 49 years. The southside of the inn had a park-like setting and was a garden spot for many years. (Courtesy of HCPL.)

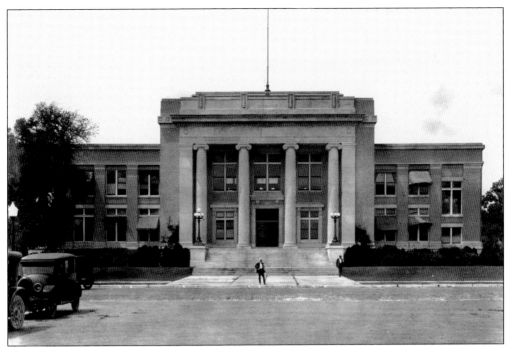

This 1924 photo shows the front of the Pinellas County Courthouse on the southwest corner of 324 Fort Harrison Avenue South intersecting with Haven Street. (Courtesy of HCPL.)

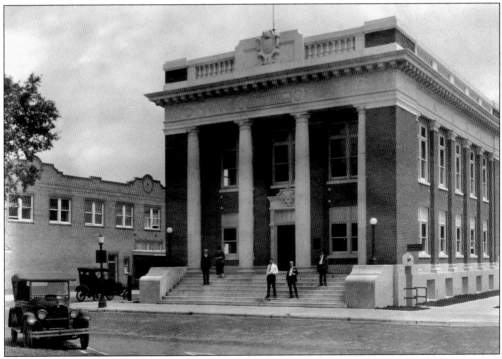

City Hall was located at the southeast corner of Fort Harrison Avenue South and Haven Street in 1924. Constructed in 1922, this building was torn down in 1978 when Court Street was reconfigured to allow one-way traffic access to Clearwater Beach. (Courtesy of HCPL.)

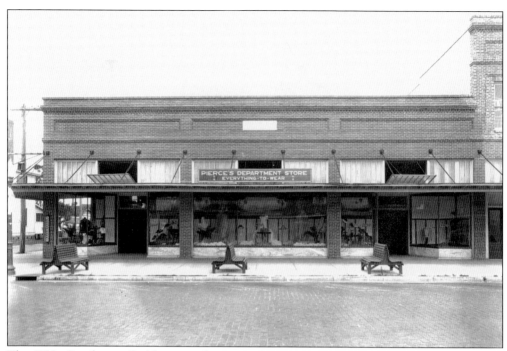

The E.H. Coachman Building was home to Pierce's Department Store on the corner of Cleveland Street and Garden Avenue. This photo was taken in 1922. (Courtesy of HCPL.)

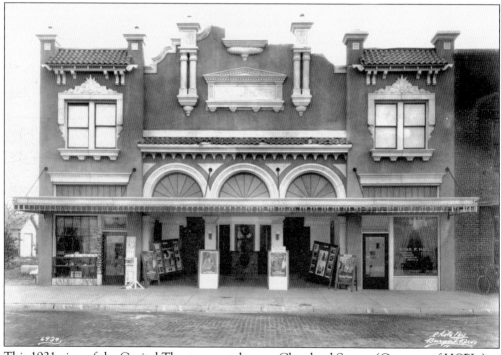

This 1921 view of the Capital Theater was taken on Cleveland Street. (Courtesy of HCPL.)

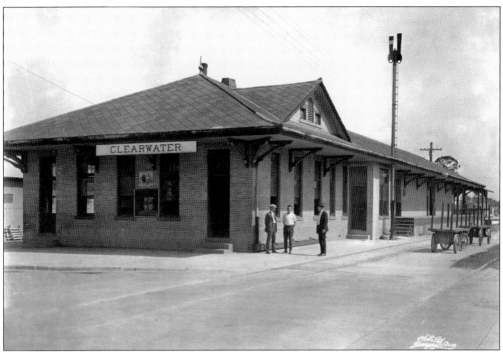

This 1922 photograph shows men standing in front of the Atlantic Coastline Railroad located at the Cleveland Street Train Station. (Courtesy of HCPL.)

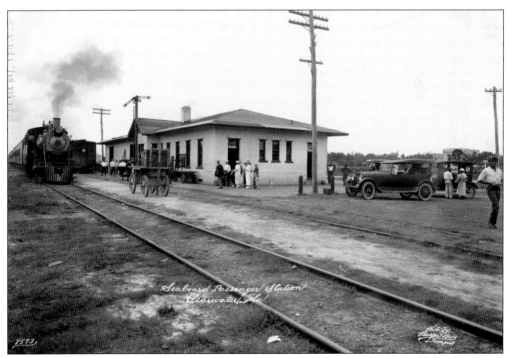

A train is arriving at the Seaboard Passenger Station at 657 Court Street in 1922. (Courtesy of HCPL.)

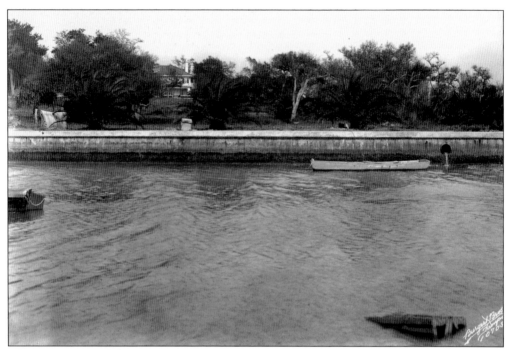

This 1924 view of the prestigious Harbor Oaks home was taken from Clearwater Harbor. (Courtesy of HCPL.)

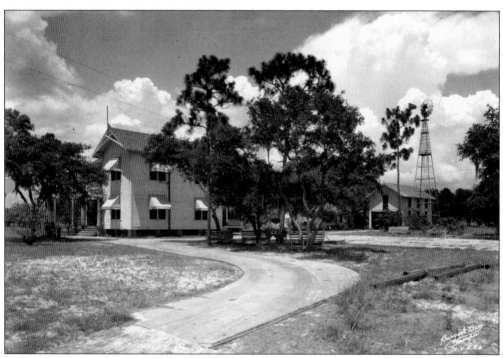

This was the residence of E.A. Marshall, photographed in 1925. It was a two-story cottage with a horse stable, windmill, and park benches under the trees for gatherings. (Courtesy of HCPL.)

This 1924 home at 410 West Druid Road in the Harbor Oaks subdivision belonged to Mayor Raymond E. Green. (Courtesy of HCPL.)

In 1924, this house was the gathering place for James Woodroffe's Mediterranean Revival. The house was located on the southwest corner of Bay Avenue and Pine Street. It was for sale at the time this photograph was taken. (Courtesy of HCPL.)

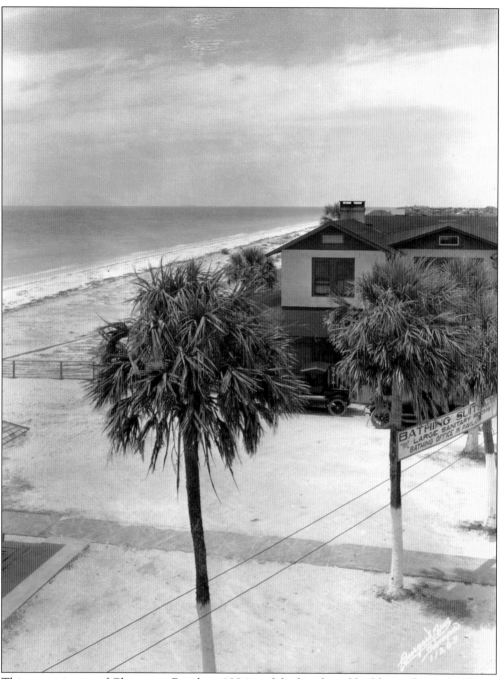

This serene image of Clearwater Beach in 1924 is of the beach and bathhouse located right on the Gulf of Mexico where crowds of people would soon enjoy the Florida sun and sea breeze. (Courtesy of HCPL.)

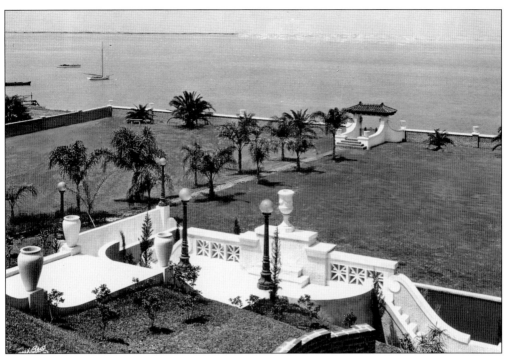

This is Clearwater Harbor looking towards Sand Key in 1924 as seen from the Robert S. Brown residence. This estate was located at 802 Druid Road and was originally owned by Dean Alvord, the land developer. This image is also seen on the cover of the book. (Courtesy of HCPL.)

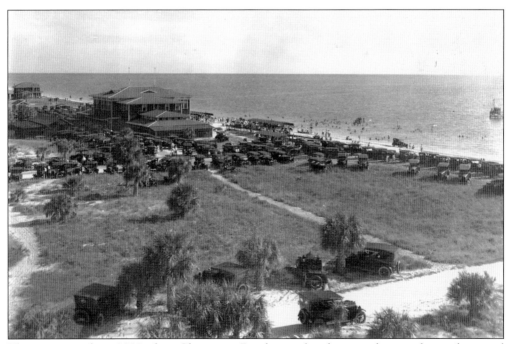

This is a scene from 1921 when Clearwater Beach was already a popular spot for residents and tourists. Notice that there was no designated parking. (Courtesy of HCPL.)

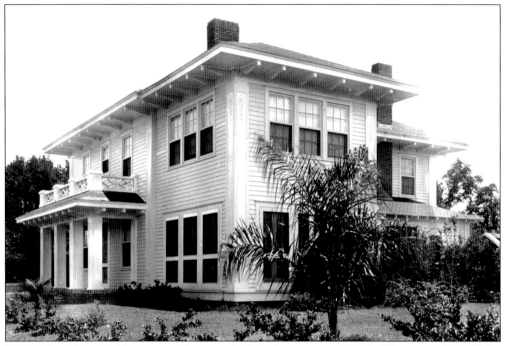

This Colonial Revival house was photographed in the summer of 1921. (Courtesy of HCPL.)

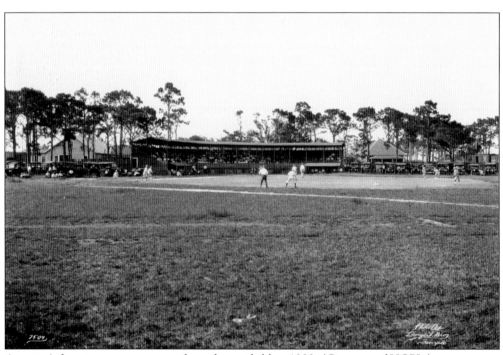

America's favorite pastime is seen from the outfield in 1922. (Courtesy of HCPL.)

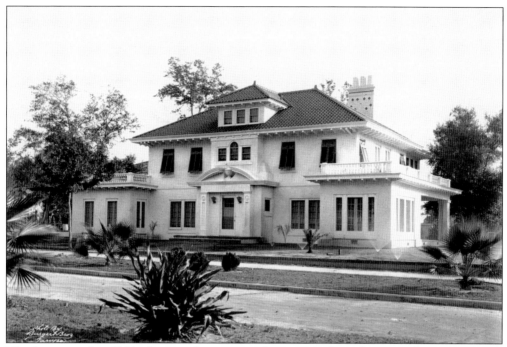

The home in this 1920 photograph was an eclectic revival residence in the Harbor Oaks subdivision. (Courtesy of HCPL.)

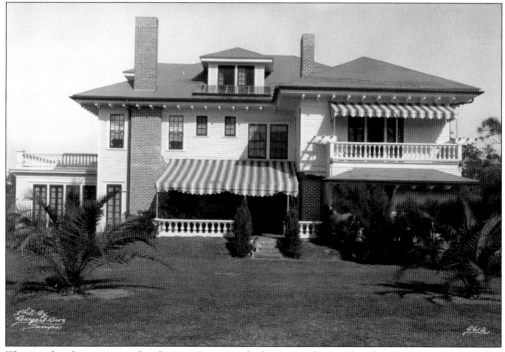

This is the front view of a Queen Anne–style home with two fireplaces and awnings. This home was located in the Harbor Oaks subdivision and was photographed in 1920. (Courtesy of HCPL.)

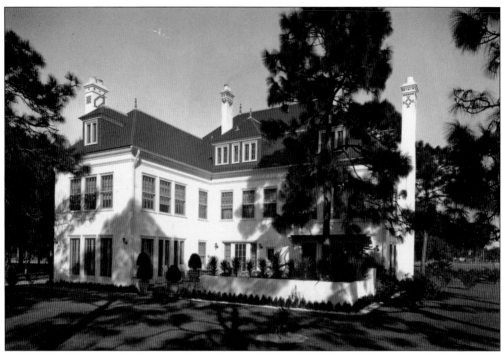

A Harbor Oaks home is pictured with a beautifully landscaped yard in 1920. (Courtesy of HCPL.)

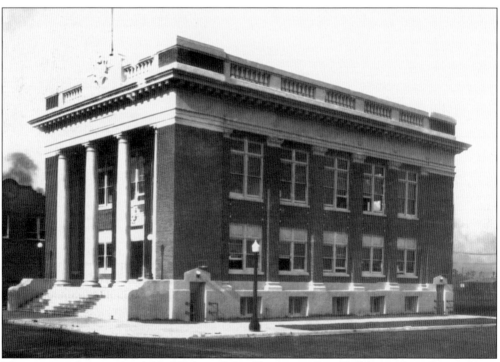

This image, taken on April 18, 1924, is of the Clearwater City Hall located on the southeast corner of Fort Harrison Avenue South. (Courtesy of HCPL.)

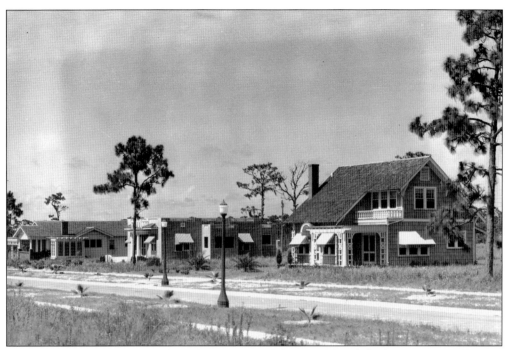

The lots in this unknown residential area were still being sold and the homes were still under construction in 1924. (Courtesy of HCPL.)

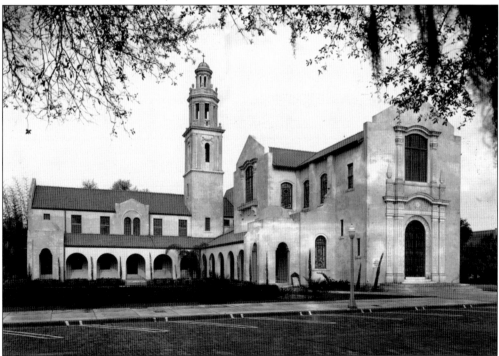

Peace Memorial Presbyterian Church was located on Fort Harrison Avenue South in 1924. It sits on the location that occupied the first temporary Pinellas County Courthouse building. (Courtesy of HCPL.)

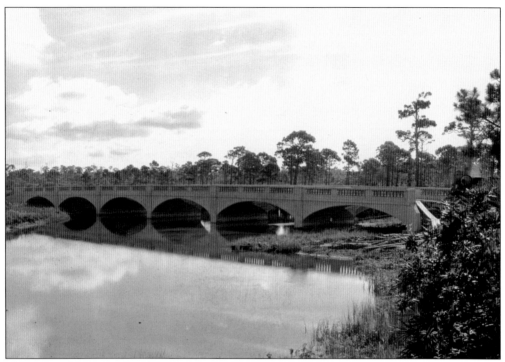

This six-arch concrete bridge with balustrade was still under construction on June 2, 1924. (Courtesy of HCPL.)

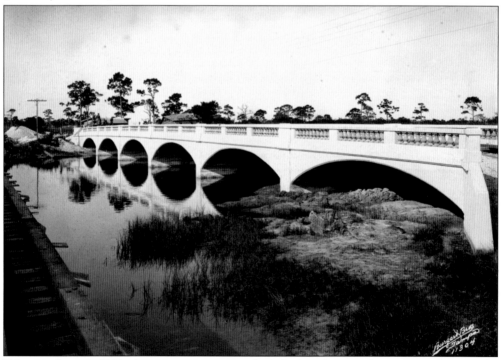

Taken on June 2, 1924, this image was captured while the photographer was standing on the railroad bridge located on the opposite side of the bridge above. (Courtesy of HCPL.)

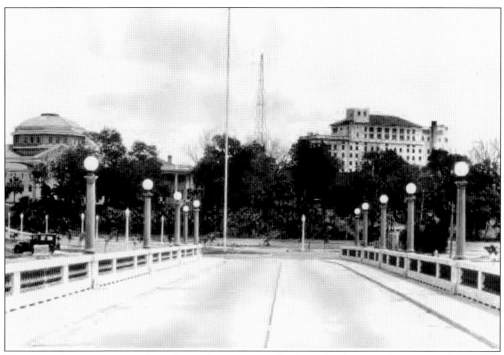

This is a 1920s photograph is from the causeway looking back towards town and the Fort Harrison Hotel. (Courtesy of FSA.)

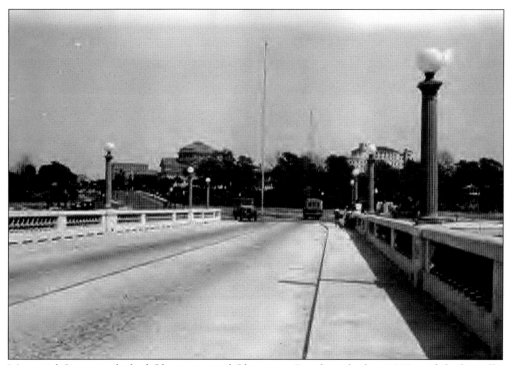

Memorial Causeway linked Clearwater and Clearwater Beach in the late 1920s with little traffic at the time this photo was taken. (Courtesy of FSA.)

The road to Clearwater shows a billboard on the right advertising the Fort Harrison Hotel with a photograph of the hotel to entice visitors, c. 1920s. (Courtesy of FSA.)

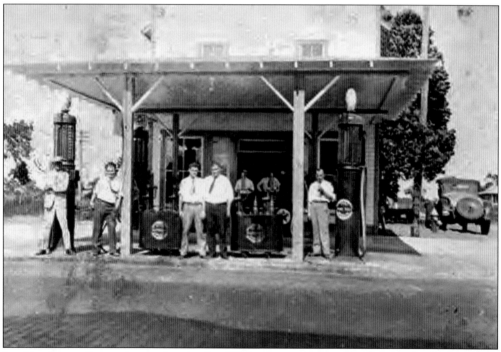

In this photo of a service station in the 1920s, the gentleman third from the left is Alton Bullard. The rest are unidentified. (Courtesy of FSA.)

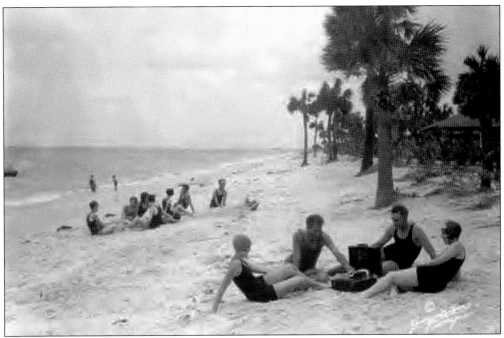

Bathers relaxing on Bellair Beach on a breezy summer day in 1926 are listening to music on their phonograph. (Courtesy of FSA.)

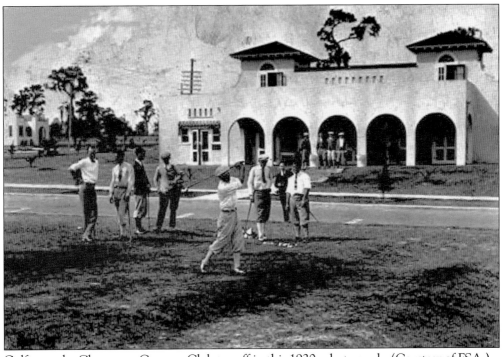

Golfers at the Clearwater Country Club tee off in this 1920s photograph. (Courtesy of FSA.)

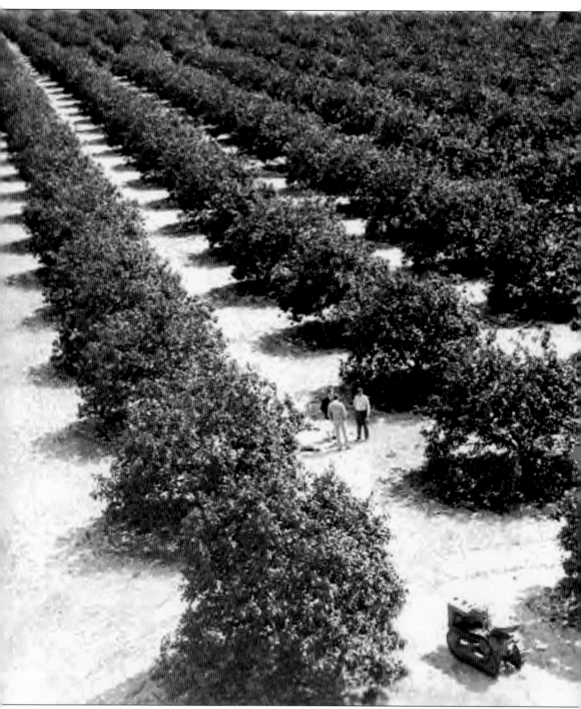

A large orange grove grows in the 1920s. Notice the gentlemen standing in the field and the tractor in the foreground. Clearwater is no longer home to the capacity of citrus found in this field; however, Florida remains the top citrus-producer in the country. Fields this size are often found in smaller Florida towns that rely on the economic stability such groves offer. (Courtesy of FSA.)

Four

1930s

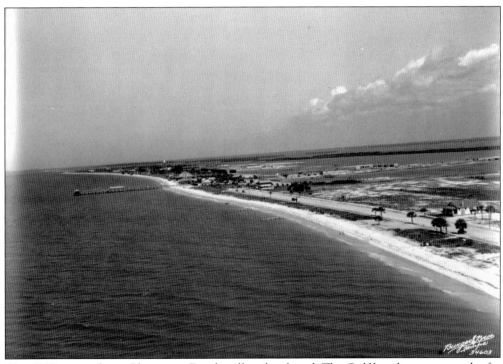

This 1932 image shows Clearwater Beach still undeveloped. The Gulf beaches were popular for rest and relaxation, a day of swimming and sunbathing, and were a great place to get a breath of fresh air. (Courtesy of HCPL.)

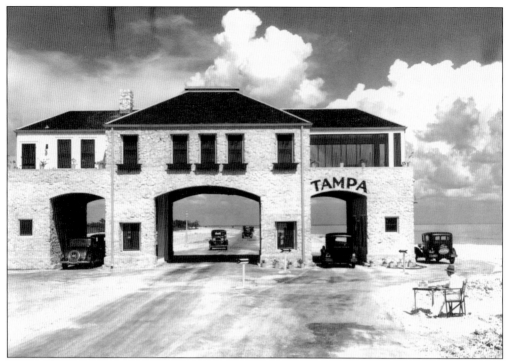

Automobile traffic is seen at the Ben T. Davis Causeway tollgate on August 26, 1934. (Courtesy of HCPL.)

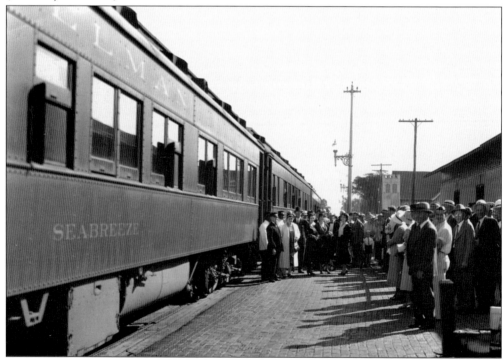

Residents are waiting for friends, family, and business associates to depart the *Seabreeze* at the Clearwater Railroad Station in 1932. (Courtesy of HCPL.)

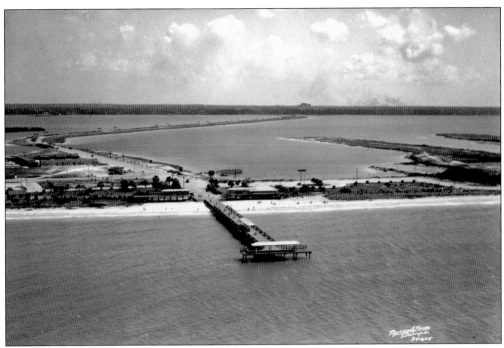

The pier on the beach with the view looking east over the Memorial Causeway to downtown Clearwater was photographed on May 7, 1932. (Courtesy of HCPL.)

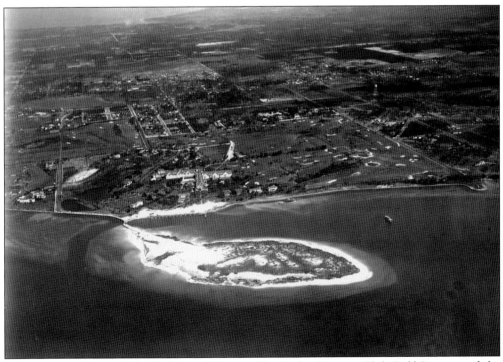

This is an aerial view of the Belleview Biltmore Hotel, the Country Club Golf Course, and the surrounding landscaped grounds in 1931. (Courtesy of HCPL.)

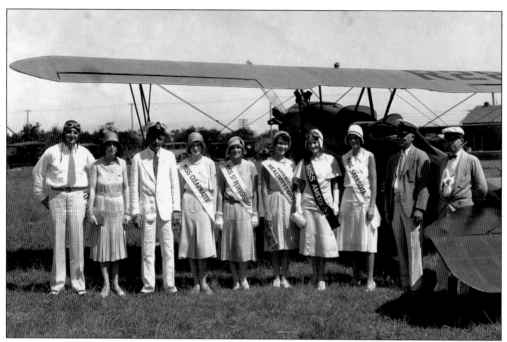

Beauty contestants pose in front of a bi-plane on July 3, 1930. Miss America is Tampa's Margaret Eckdahl and Florida's Healthiest Girl is Florence Smock of Eustis, Florida. The men on the right are identified as Mayor H.H. Baskin of Clearwater and R.B. Norton, president of the Clearwater Chamber of Commerce. (Courtesy of HCPL.)

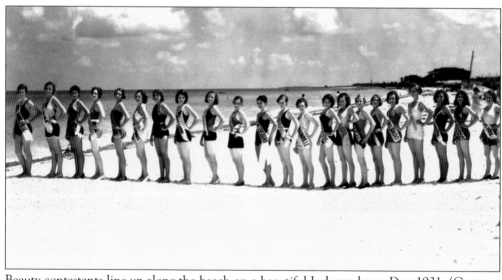

Beauty contestants line up along the beach on a beautiful Independence Day, 1931. (Courtesy of HCPL.)

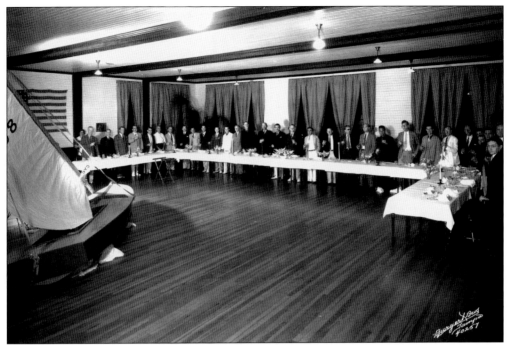

Members of the Clearwater Yacht Club are standing at tables making a toast in 1937. The club was located at 531 Mandalay Boulevard. (Courtesy of HCPL.)

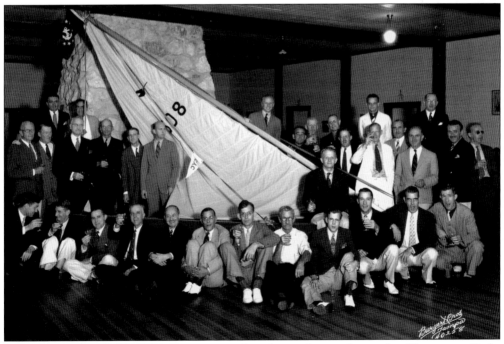

This photo, dated the same evening as the photo above, shows the Clearwater Yacht Club Members posed in front of the sailboat that was sitting in the middle of this room. (Courtesy of HCPL.)

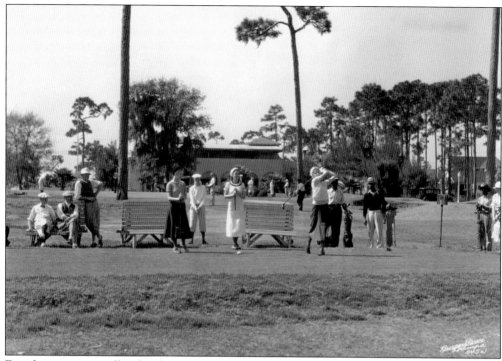

Female tourists tee off with other golfers in 1932. (Courtesy of HCPL.)

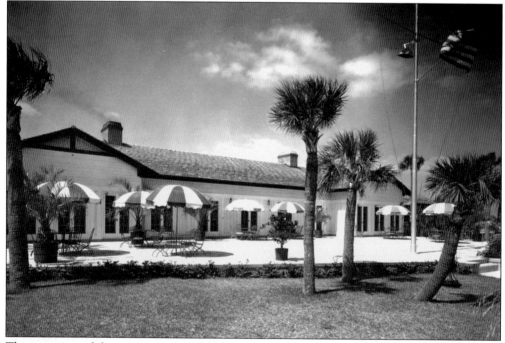

This is a view of the exterior patio of the Carlouel Yacht Club in 1937. This prestigious club offered activities of swimming, tennis, dancing, and other functions for its wealthy members. It was named after the wives of the founding partners—*Ca*rolyn Hobert, *Louise* Palmer, and *El*eanor Randolph. (Courtesy of HCPL.)

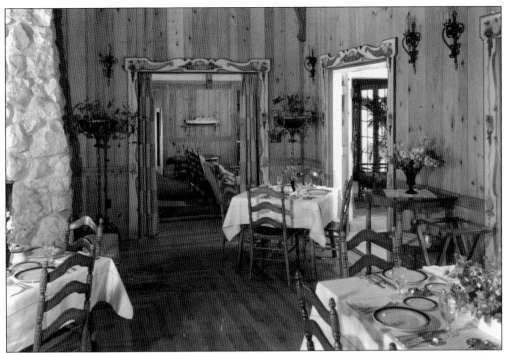

The dining room of the Carlouel Yacht Club has tables set for dinner in 1937. (Courtesy of HCPL.)

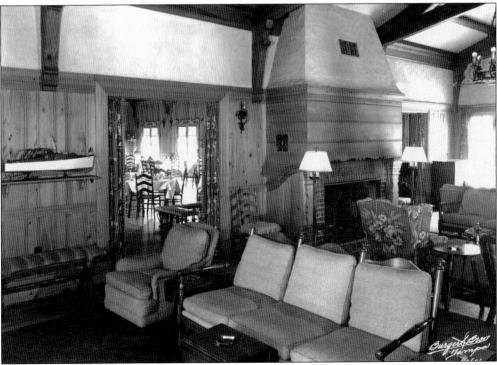

The interior lounge of the Carlouel Yacht Club made guests feel at home. It was located adjacent the dining room and had a nautical décor. (Courtesy of HCPL.)

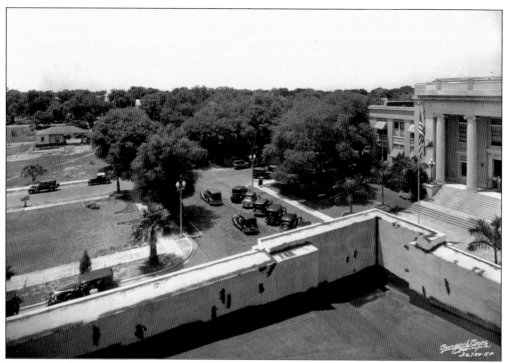

An elevated view of the street, parkway, and partial front facade of the Pinellas County Courthouse is seen in 1934. (Courtesy of HCPL.).

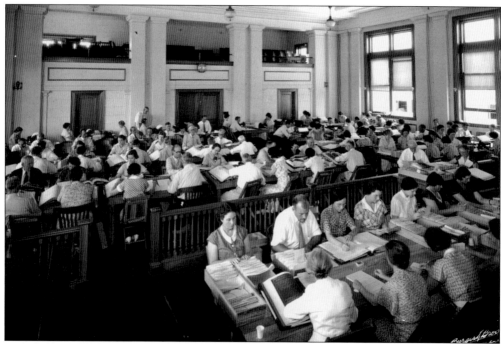

This 1936 photograph captured Pinellas County Courthouse employees doing paperwork with various registers and files. (Courtesy of HCPL.)

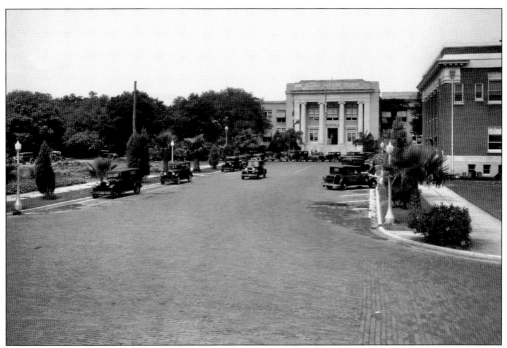

This image in 1934 depicts the Pinellas County Courthouse on Fort Harrison Avenue with traffic parked on either side of the street. (Courtesy of HCPL.)

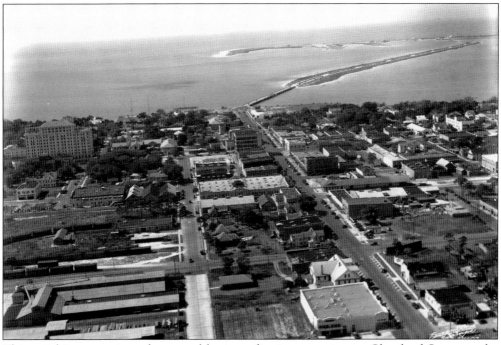

This aerial image projects the central business district, centering on Cleveland Street, to the Inter-coastal Waterway Memorial Causeway leading to Clearwater Beach Island in 1932. (Courtesy of HCPL.)

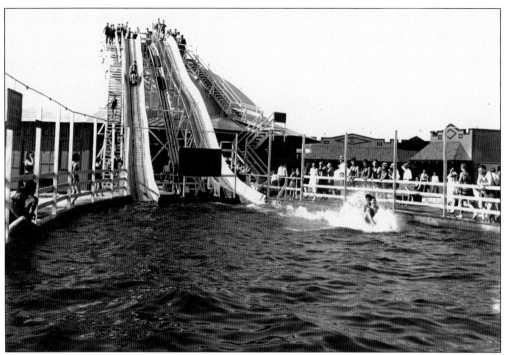

Beach-goers are having a great time at this popular Joyland water slide and pool that was on Clearwater Beach in 1930. (Courtesy of HCPL.)

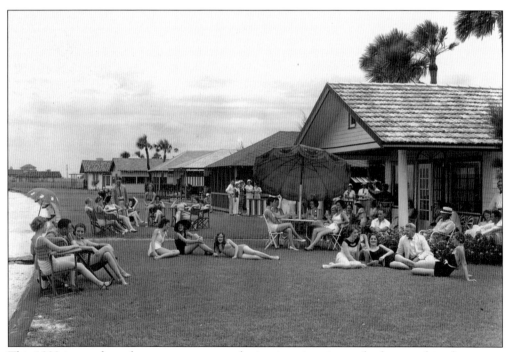

This 1933 image shows beauty contestants relaxing in swimsuits on the lawn and in chairs near Clearwater Beach's Carlouel Country Club just before competition began. (Courtesy of HCPL.)

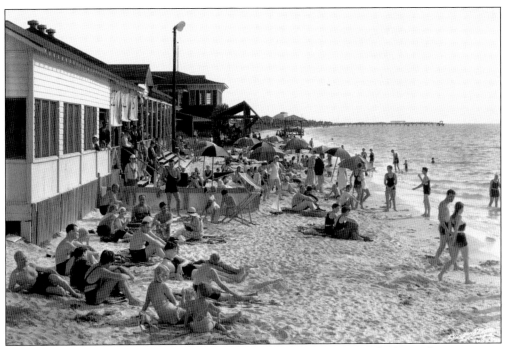

Beach-goers are enjoying a day at the beach in 1932 near concessions, baths, and amusements. This view is south along the water towards the pier.

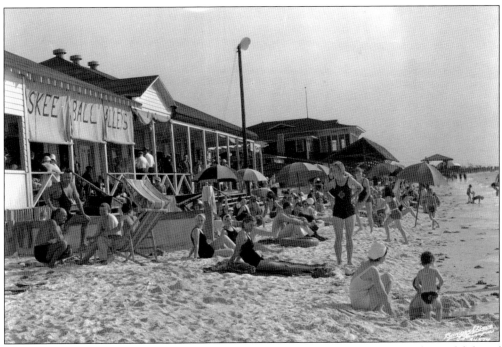

The scene in Clearwater Beach in 1932 shows tourists and residents enjoying a beautiful day of sun and fun near the bathhouse and concession stand. (Courtesy of HCPL.)

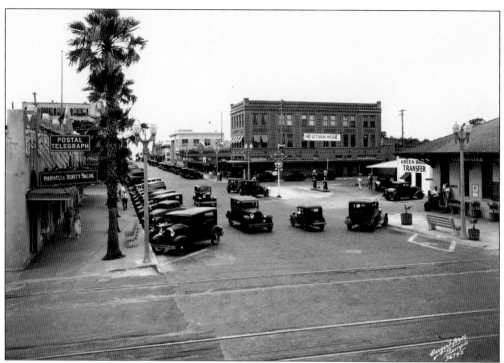

Local traffic moves along Cleveland Street in 1934 at the central business district of Clearwater, with the telegraph and post office on the left and the train station on the right. (Courtesy of HCPL.)

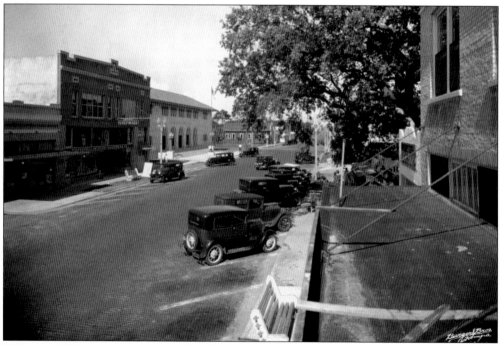

Taken in 1934, this is the scene of parked cars across the street from the Whitesel-McClung Hardware Company. (Courtesy of HCPL.)

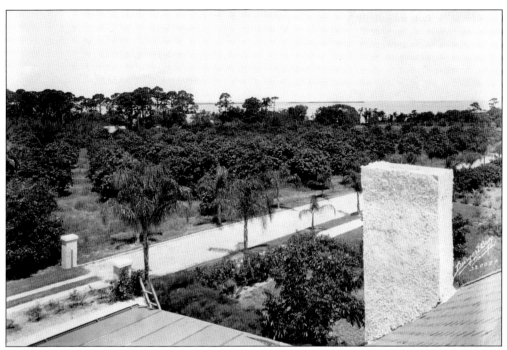

Florida agriculture has always been one of the main resources of survival. This 1930 image of a citrus grove was taken from a rooftop with the Gulf in the background. (Courtesy of HCPL.)

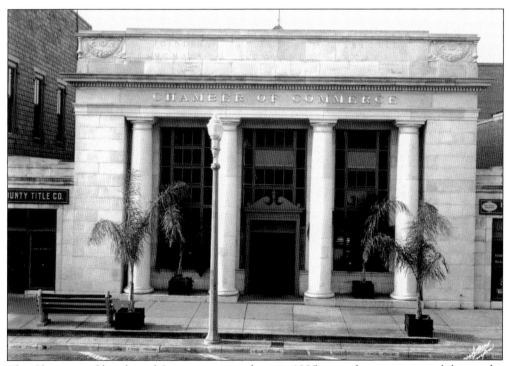

The Clearwater Chamber of Commerce, seen here in 1935, provides economic stability to the city. (Courtesy of HCPL.)

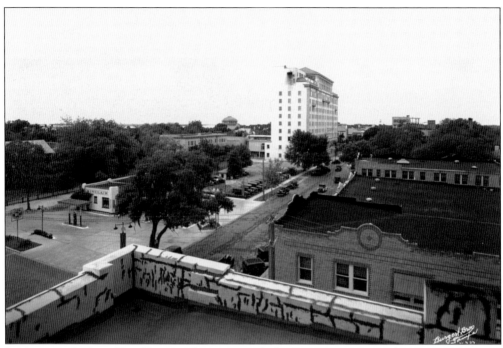

Looking north down Fort Harrison Street towards the Fort Harrison Hotel in 1934. (Courtesy of HCPL.)

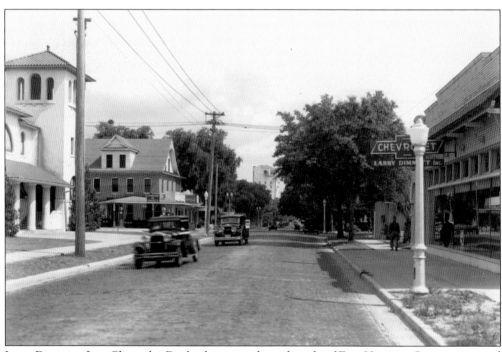

Larry Dimmitt, Inc. Chevrolet Dealership is on the right side of Fort Harrison Street as it stood in 1934. (Courtesy of HCPL.)

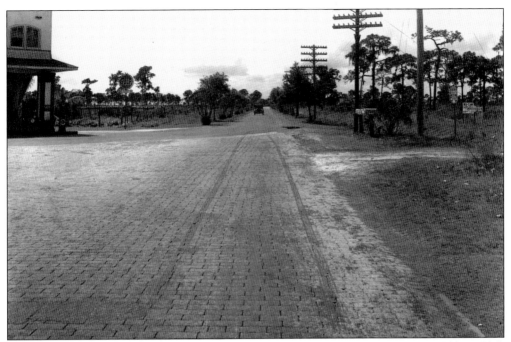

This rural brick crossroad includes a Gulf Service Station and signage from Tampa Motor Club showing the Clearwater and West Tampa routes in 1935. (Courtesy of HCPL.)

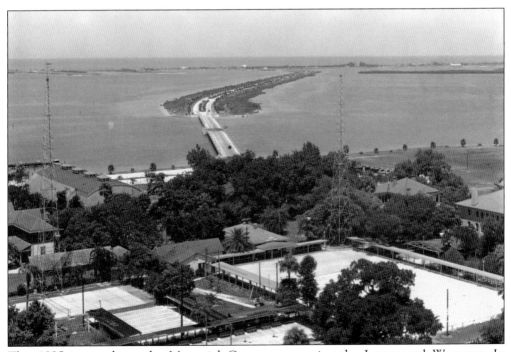

This 1935 image shows the Memorial Causeway spanning the Intracoastal Waterway. In the foreground is the construction of the Lawn Bowling Court, which was once a popular recreational activity for senior citizens in the 1930s and 1940s. (Courtesy of HCPL.)

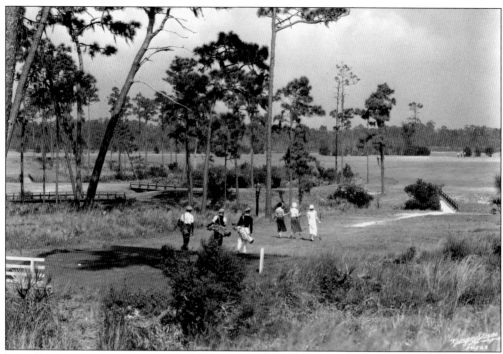

This 1932 image shows female tourists, accompanied by their caddies, as they stroll down the fairway towards the green. (Courtesy of HCPL.)

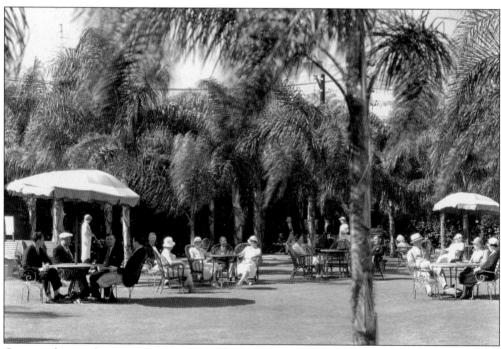

Guests relax at the Fort Harrison Hotel's palm-shaded gardens, catching up on gossip and business matters. The economy was still recovering in 1932. (Courtesy of HCPL.)

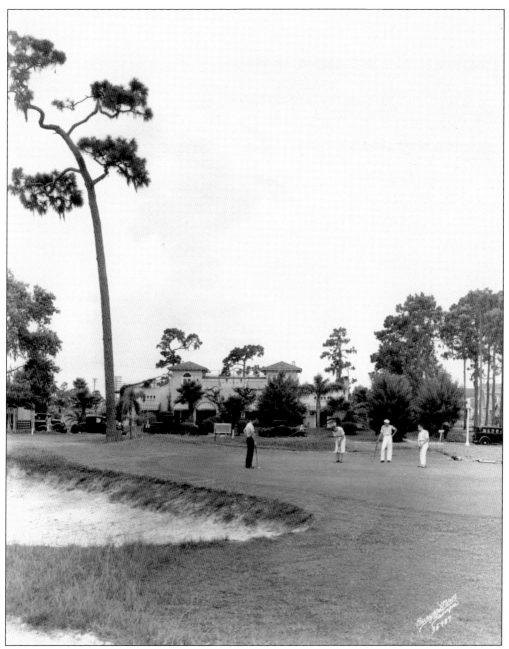

Golfers are putting on the green near a sand trap at the Clearwater Country Club in 1933. (Courtesy of HCPL.)

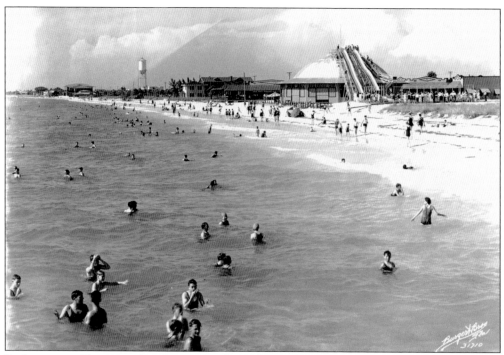

Bathers enjoy Clearwater Beach in 1930; the Joyland Silver Dome recreational slide is pictured in the background. (Courtesy of HCPL.)

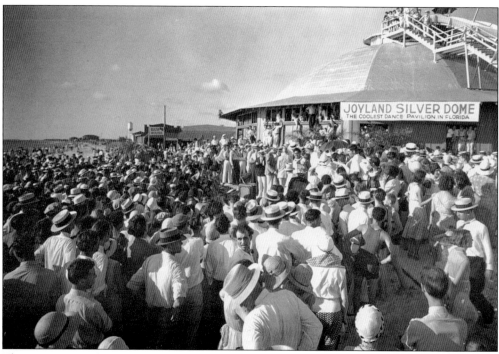

The Pajama Parade promotion draws a large crowd at the Joyland Silver Dome slide area in 1931. (Courtesy of HCPL.)

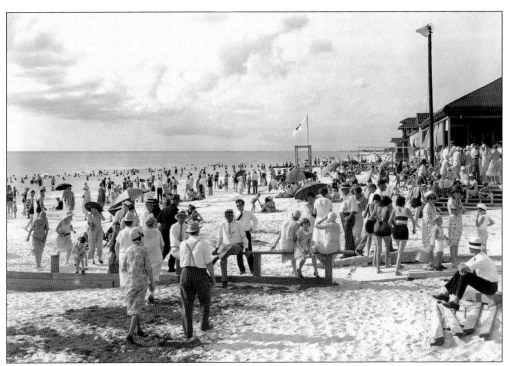

This 1930s scene shows a crowded Clearwater Beach, both in and out of the water. (Courtesy of HCPL.)

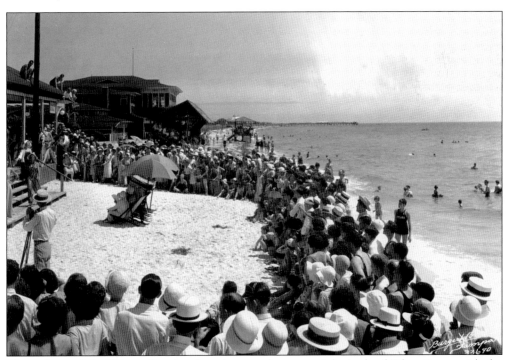

The judging of the Pajama Parade takes place on the steps of the Joyland Silver Dome with the crowd anticipating the outcome on Independence Day, 1931. (Courtesy of HCPL.)

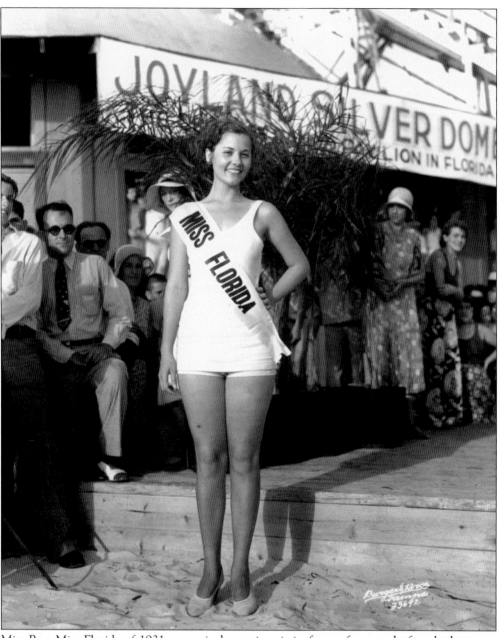

Miss Rey, Miss Florida of 1931, poses in her swimsuit in front of a crowd of on-lookers at a promotion for the Joyland Silver Dome. (Courtesy of HCPL.)

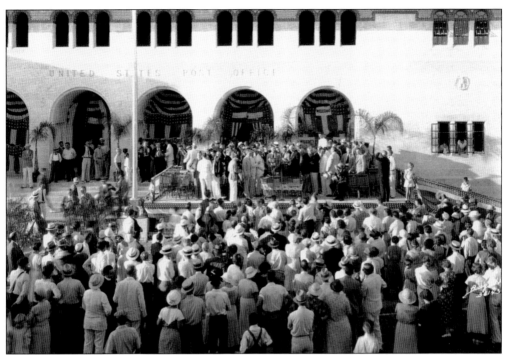

A crowd gathers to listen to speakers at the dedication of the United States Post Office in 1933. (Courtesy of HCPL.)

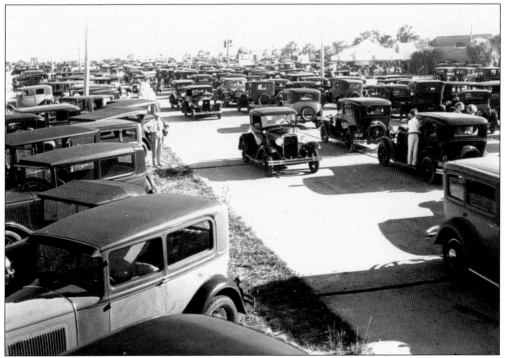

This 1931 photo shows a traffic jam and the excited patrons making their way to an offshore speedboat event at Clearwater Beach. (Courtesy of HCPL.)

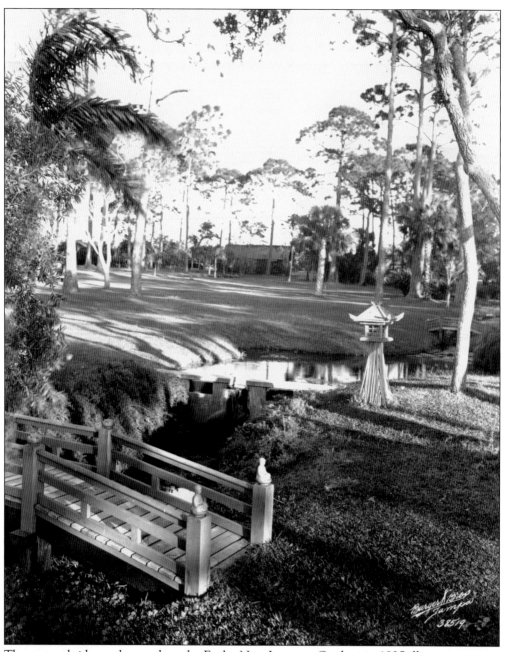

The stream-bridge and grounds at the Eagles Nest Japanese Gardens in 1935 illustrate serenity at its best. (Courtesy of HCPL.)

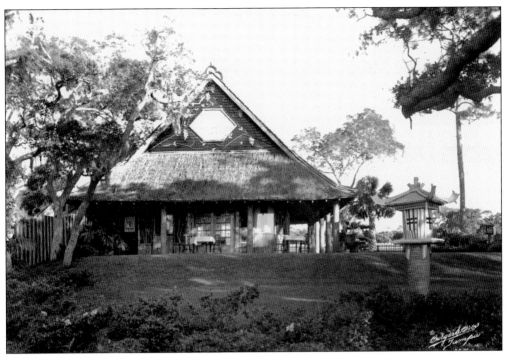

The Eagles Nest Japanese Garden teahouse is pictured with a peaked thatched roof in 1935. (Courtesy of HCPL.)

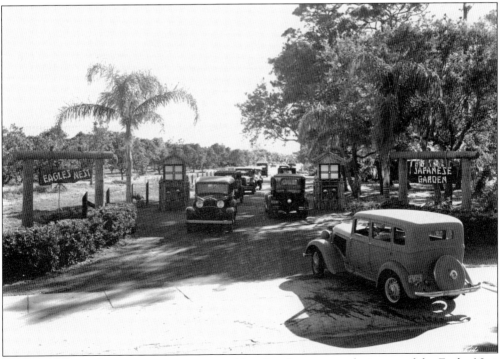

This 1935 image shows patrons entering and leaving the entrance/exit gate of the Eagles Nest Japanese Gardens. (Courtesy of HCPL.)

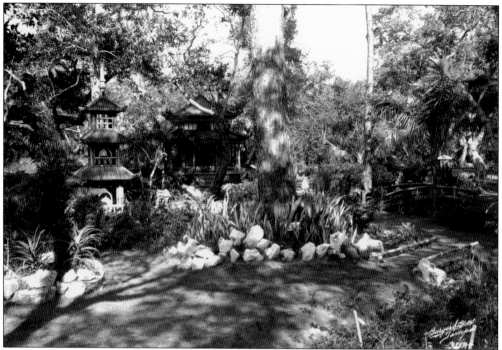

The temple and surrounding grounds of the Eagles Nest Japanese Gardens with pagoda and bridge are pictured on December 4, 1935. (Courtesy of HCPL.)

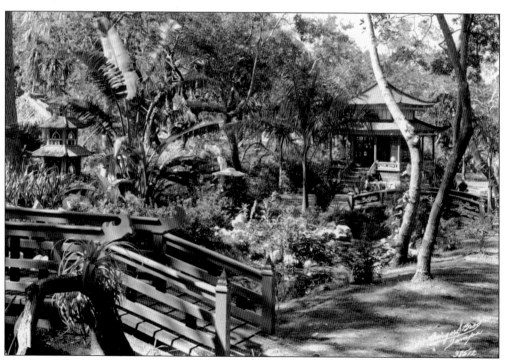

Another 1935 photo shows Eagles Nest Japanese Gardens bridge with landscaping in the foreground and a tearoom in the background. (Courtesy of HCPL.)

Five

1940s

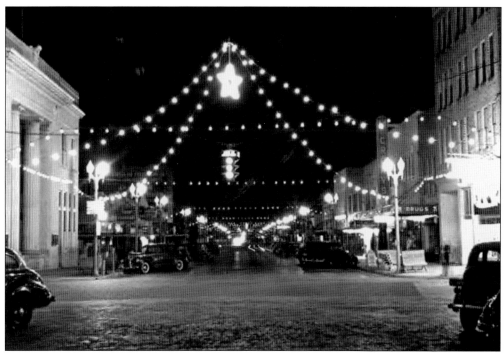

This photograph, dated 1941, is looking east up Cleveland Street at the intersection of Fort Harrison Avenue in the foreground. To the left is the Bank of Clearwater; the street is decorated for the Christmas holiday. This image was taken soon after the United States entered into World War II. It was taken by J. Arlos Studio, a well-known photography studio in Clearwater for many years. (Courtesy of CPL.)

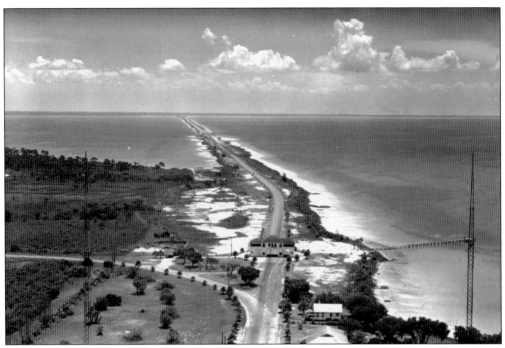

A 1943 aerial view shows the Ben T. Davis Causeway looking east towards Tampa. The workers in the tollbooth are awaiting vehicles leaving for Tampa. (Courtesy of HCPL.)

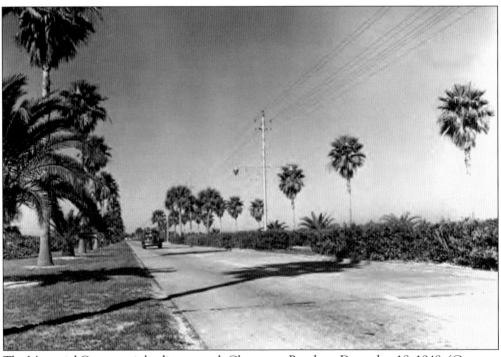

The Memorial Causeway is leading towards Clearwater Beach on December 18, 1948. (Courtesy of FSA.)

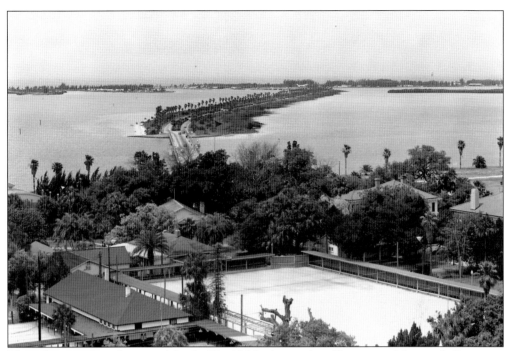

This photograph, taken on March 27, 1946, shows the Clearwater Memorial Causeway west towards the beach. In the foreground is the Clearwater Bowling Lawn, which was later transformed into additional parking for City Hall. (Courtesy of HCPL.)

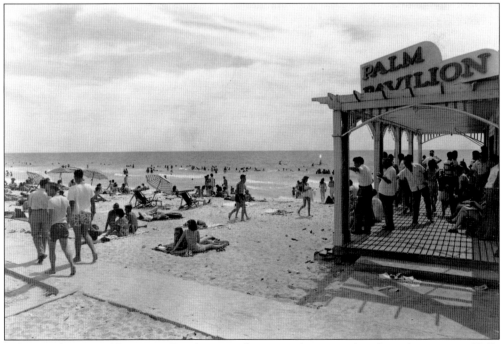

Palm Pavilion on Clearwater Beach was a hot spot for many beach enthusiasts in 1949. (Courtesy of HCPL.)

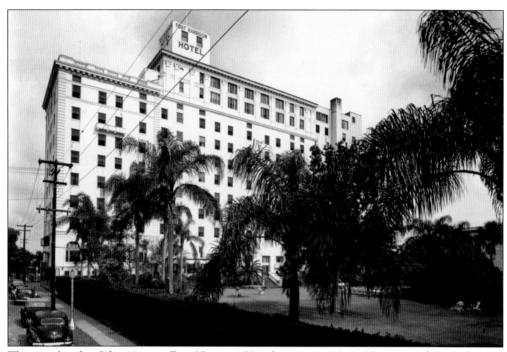

The rear facade of the 11-story Fort Harrison Hotel is seen in 1946. (Courtesy of HCPL.)

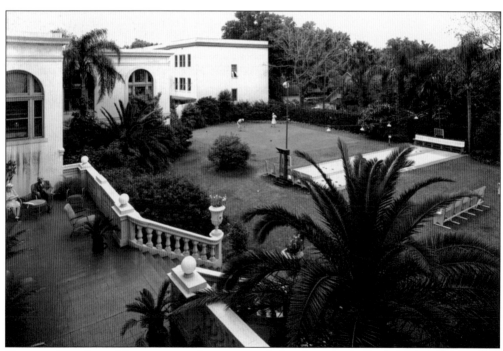

Guests enjoy a peaceful moment on the terrace, while others enjoy the shuffleboard court and putting green on the lawn terrace of the Fort Harrison Hotel in 1946. (Courtesy of HCPL.)

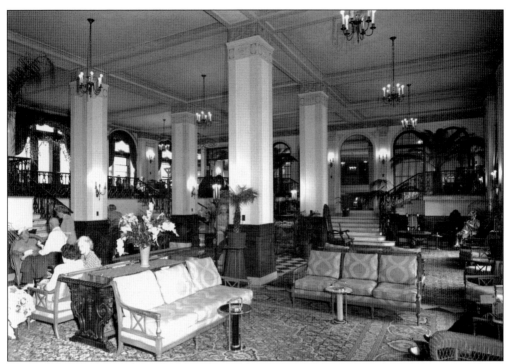

The Fort Harrison Hotel's architectural appeal was one of the most lavish in Clearwater. This is the guest lobby in 1946. (Courtesy of HCPL.)

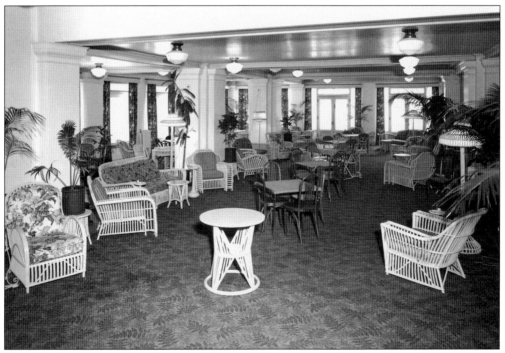

The Palm Room at the Fort Harrison Hotel in 1946 is decorated with white upholstered rattan furniture, potted palms, and leaf-patterned carpeting. (Courtesy of HCPL.)

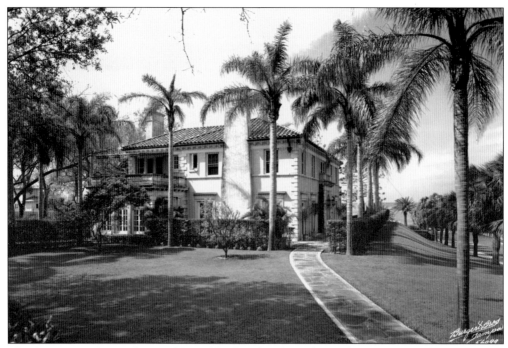

This home was the residence of Donald Alvord and was located at 205 Magnolia Avenue, *c.* 1945 (Courtesy of HCPL.)

Middle-class stucco homes on Coachman Road were photographed on March 3, 1945. (Courtesy of HCPL.)

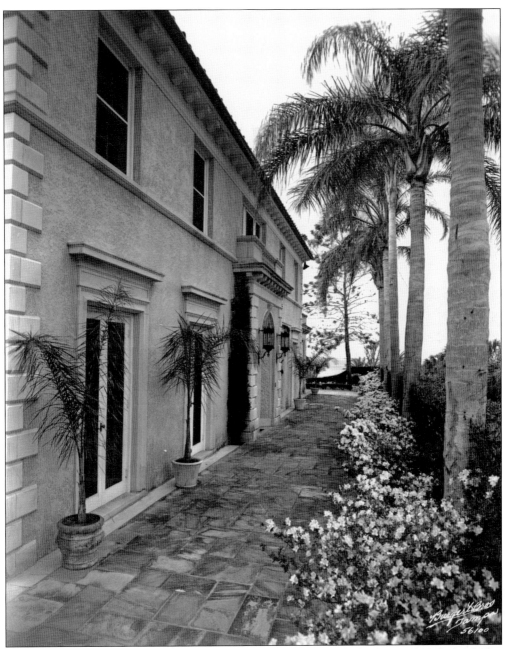

This home, belonging to Donald Alvord, could be seen from the Intra-coastal Waterway. This is a beautifully landscaped side view with azaleas and palms giving the home a personal touch, pictured on February 27, 1945. (Courtesy of HCPL.)

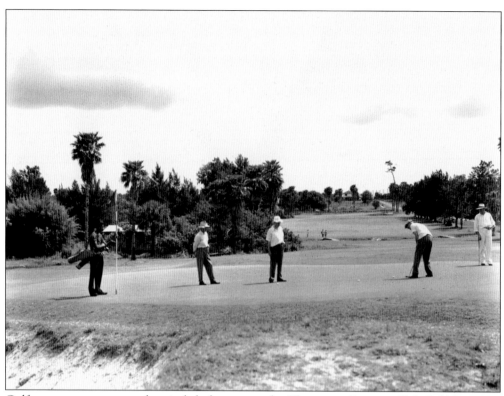

Golfers prepare to putt on the ninth-hole green at the Clearwater Country Club Golf Course in 1946. (Courtesy of HCPL.)

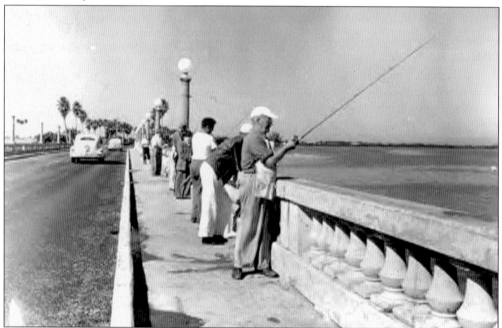

Saltwater fishing is a favorite activity in Florida and many tourists come to Clearwater to fish from the bridge, such as the patrons in this 1948 photo. (Courtesy of FSA.)

Dean Alvord's residence at the Eagle's Nest Garden is shown here. Alvord and his brother, Donald, were New York developers who used subdivision planning methods in Clearwater to create the exclusive Harbor Oaks subdivision. Dean also built beautiful Japanese Gardens, which was renamed in 1945 because of the Pearl Harbor invasion of 1941. It lost popularity and was eventually sold and subdivided for several private home sites. (Courtesy of HCPL.)

The causeway is shown in the background in October 1949. (Courtesy of FSA.)

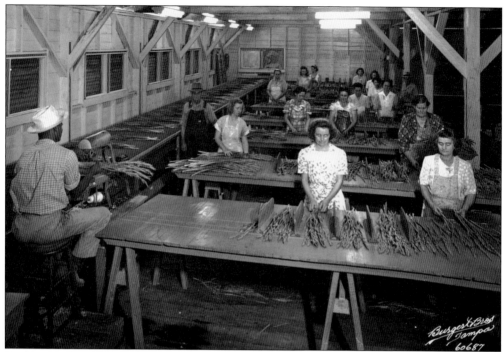

Employees of the A&W Bulb Company stand at tables sorting gladiolus, *c.* 1946. (Courtesy of HCPL.)

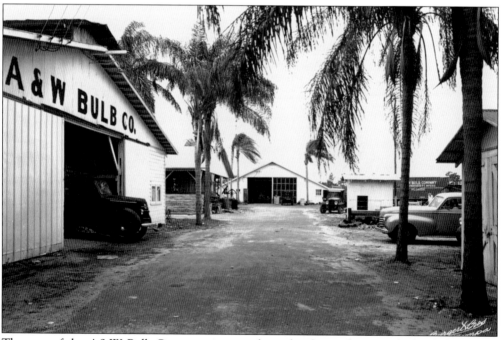

The rear of the A&W Bulb Company is seen along the drive where trucks loaded, *c.* 1946. (Courtesy of HCPL.)

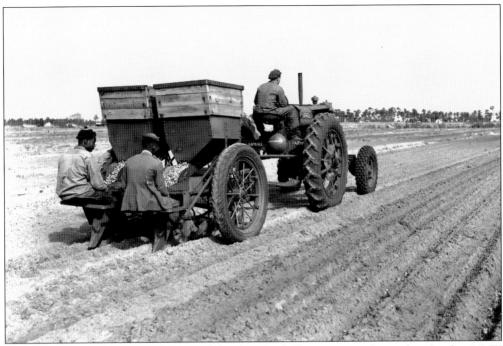

Agriculture workers sit on a tractor while planting bulbs in prepared trenches for the A&W Bulb Company in 1946. (Courtesy of HCPL.)

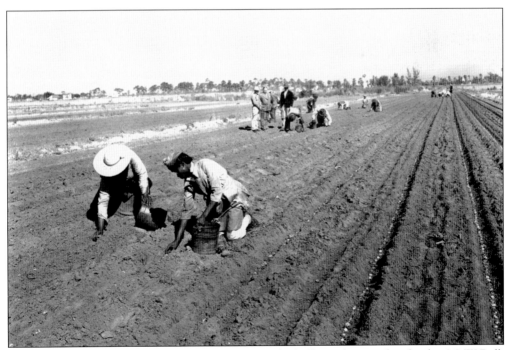

In 1946, these agriculture workers are hand setting the bulbs in the trenches for the A&W Bulb Company. (Courtesy of HCPL.)

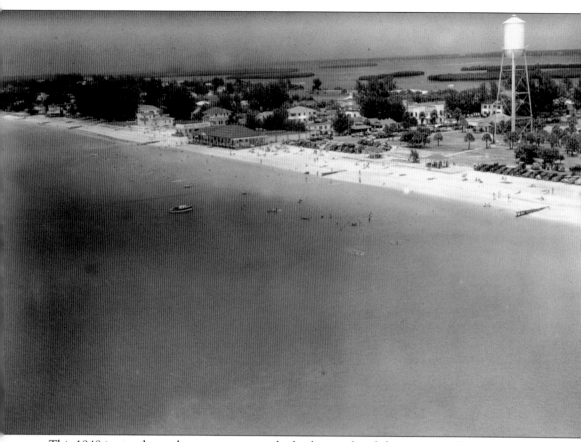

This 1948 image shows the water tower in the background and the gorgeous Clearwater Beach in the foreground with many different recreational activities in progress. (Courtesy of HCPL.)

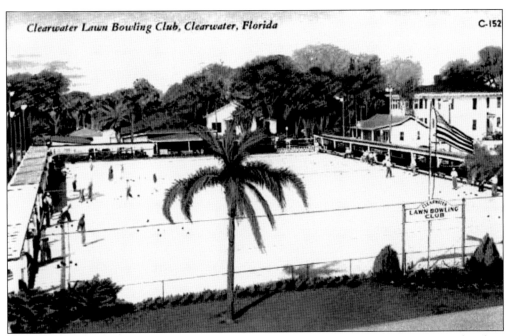

Clearwater Lawn Bowling Club was popular with senior citizens in the 1940s. Lawn bowling was a very competitive activity in its day. (Courtesy of FSA.)

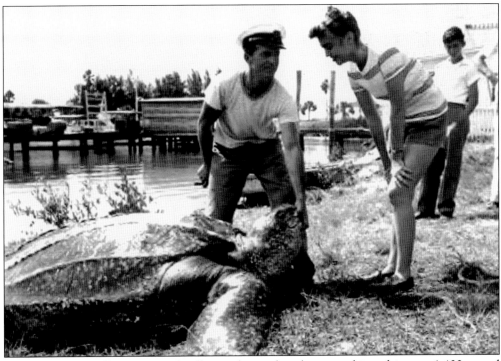

Capt. Severian Villa is pictured telling a bystander about catching this rare 1,400-pound leatherback turtle. The photo was taken at Sportsman's Dock. The charter boat was *Kingfish*, c. 1947. (Courtesy of FSA.)

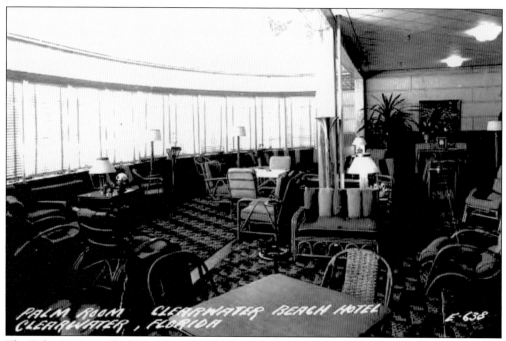

The Palm Room in the Clearwater Beach Hotel is shown in 1946. (Courtesy of FSA.)

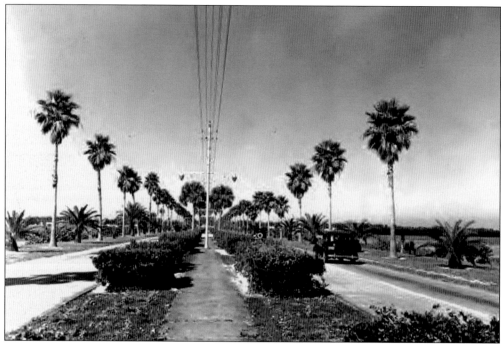

Palms line both sides of the divided Memorial Causeway leading to Clearwater Beach in 1948. (Courtesy of FSA.)

Six

1950s–1970s

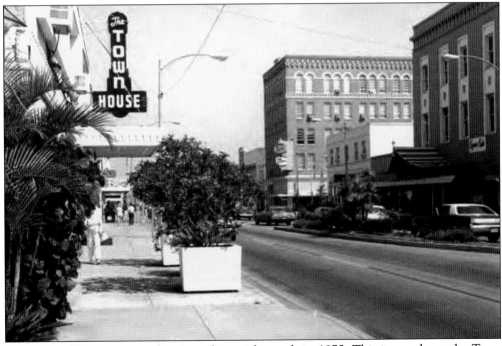

Downtown Clearwater was showing substantial growth in 1975. This image shows the Town House Motel on the left that was located at 1471 Court Street. (Courtesy of FSA.)

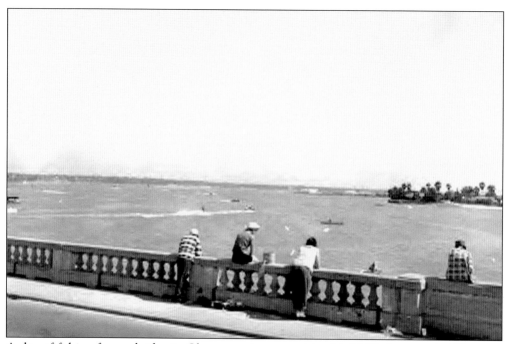

A day of fishing from a bridge in Clearwater is captured in this 1958 photograph. (Courtesy of FSA.)

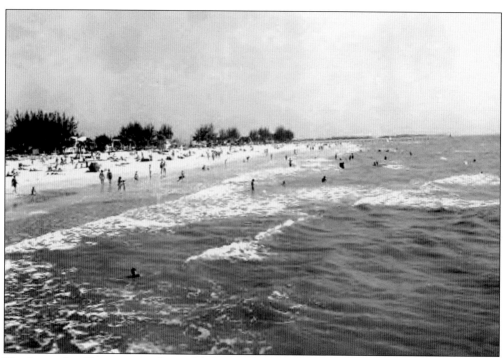

Tourists and residents enjoy a beautiful day at Clearwater Beach in 1958. (Courtesy of FSA.)

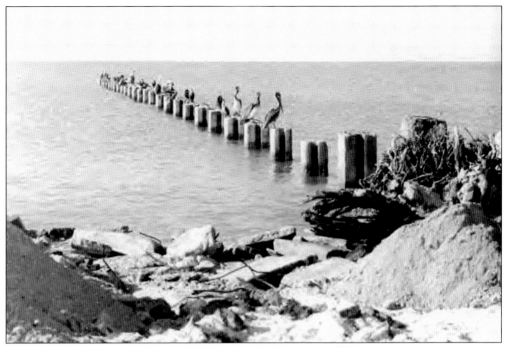
Pelicans rest on cement pilings in the bay in 1965. (Courtesy of FSA.)

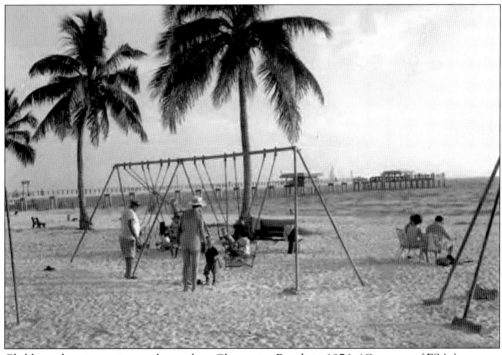
Children play on a swing set located on Clearwater Beach in 1976. (Courtesy of FSA.)

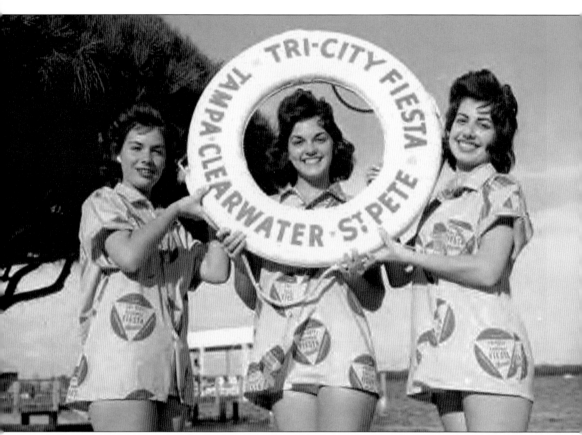

Three young women on the beach pose for the camera at the Tri-City Suncoast Festival in 1961. (Courtesy of FSA.)

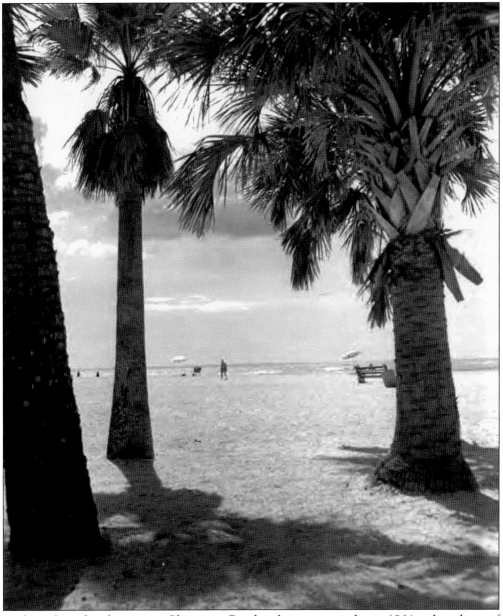

Looking through palm trees at Clearwater Beach, a breezy, sunny day in 1964 is the subject of this photograph. (Courtesy of FSA.)

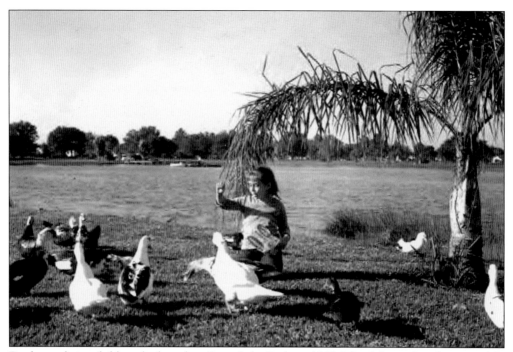

Ducks are being fed by a little girl at Crest Lake Park in 1965. This lake and park were solely dedicated for children. (Courtesy of FSA.)

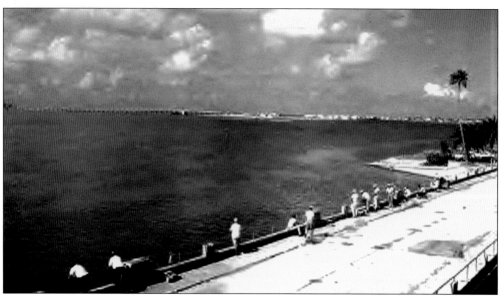

Fishing from a bridge in Clearwater is enjoyed in 1964. (Courtesy of FSA.)

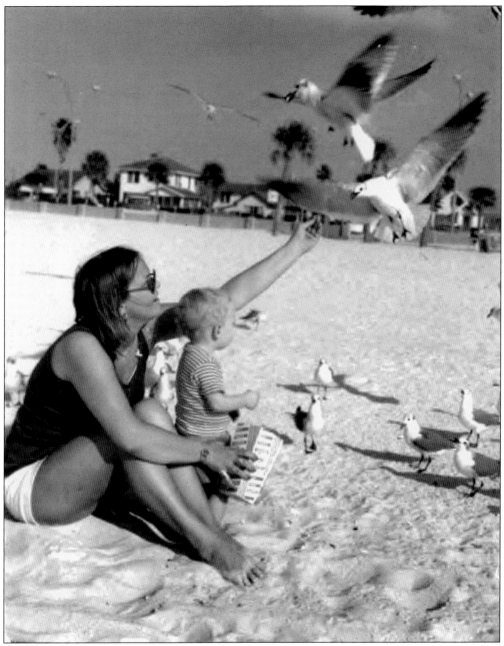

A woman and toddler are feeding the seagulls at Clearwater Beach in 1976. (Courtesy of FSA.)

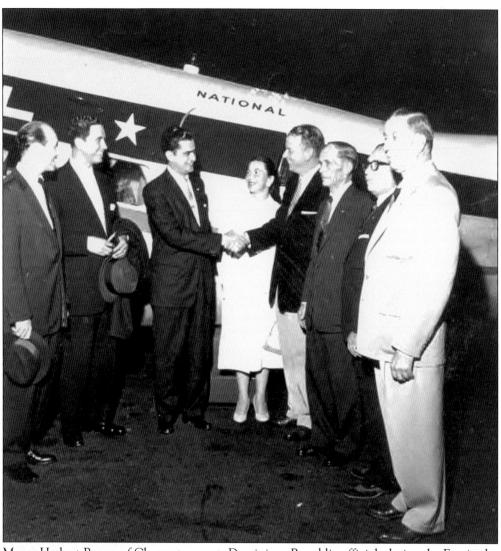

Mayor Herbert Brown of Clearwater greets Dominican Republic officials during the Fun in the Sun Festival in 1956. (Courtesy of FSA.)

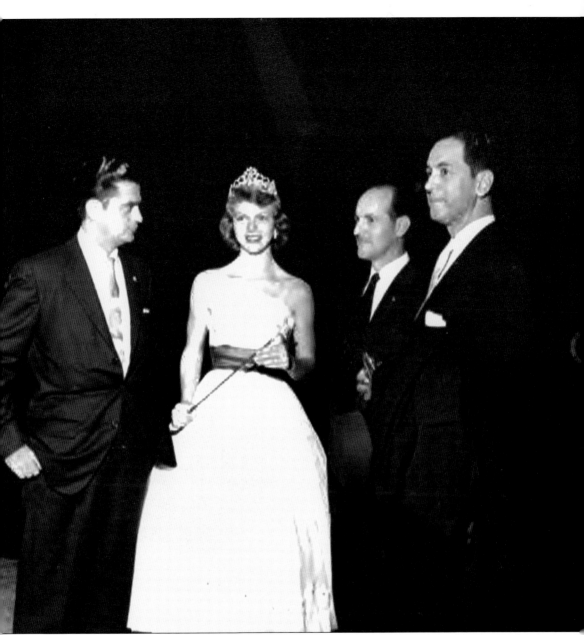

Miss Clearwater 1956, Jil Kirk, poses with the Dominican Republic officials at the Fun in the Sun Festival. (Courtesy of FSA.)

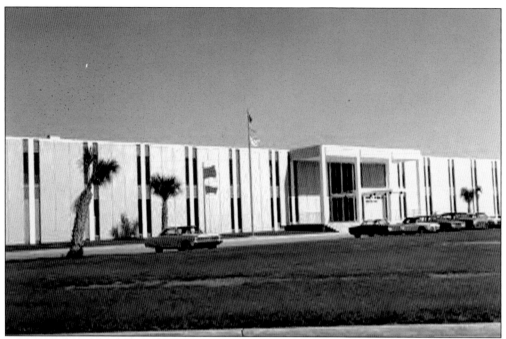

John F. Kennedy Junior High School in 1965 opened its doors for 1,188 students and 51 staff members. This 90,881-square-foot school cost $838,000 to build. It was initially called Clearwater Junior High School and was renamed shortly after the assassination of President Kennedy. (Courtesy of FSA.)

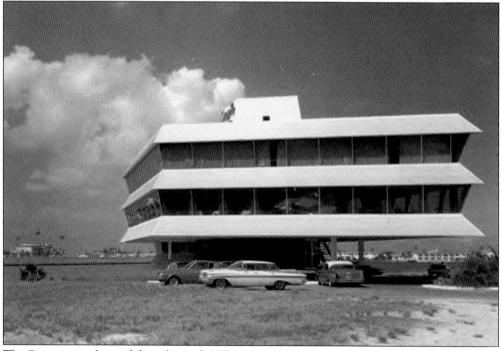

The Seaspire was located directly on the Clearwater Waterway in 1964. (Courtesy of FSA.)

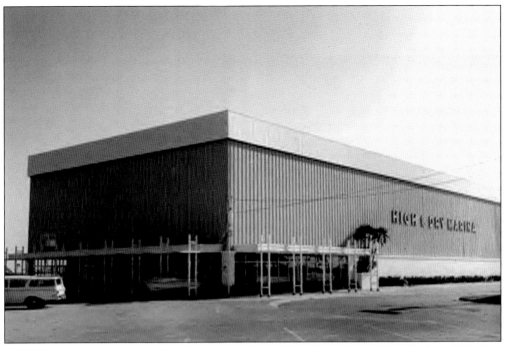

Clearwater Beach Boating Marina advertised the storage facility as being "High and Dry" in 1965. (Courtesy of FSA.)

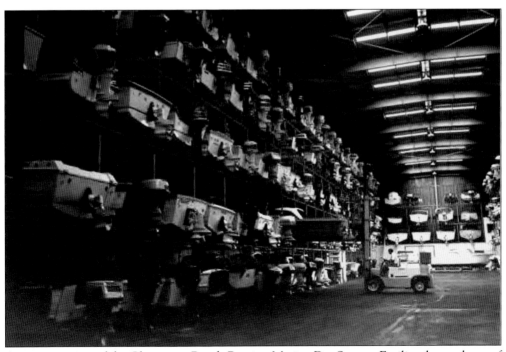

An interior view of the Clearwater Beach Boating Marina Dry Storage Facility shows plenty of business in 1965. (Courtesy of FSA.)

A beautiful view of the bay includes the Horizon House and Island Estates in the background in 1964. (Courtesy of FSA.)

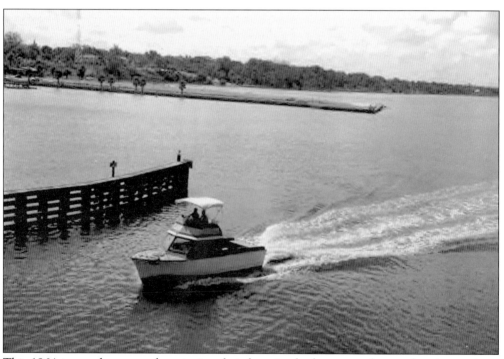

This 1964 image shows people enjoying their boat in the bay, one of many favorite pastimes enjoyed by tourists and residents. (Courtesy of FSA.)

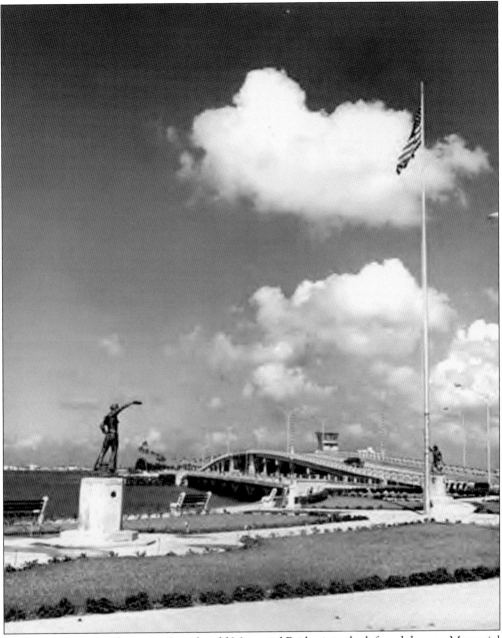

Looking west across Clearwater Bay, the old Memorial Bridge is to the left and the new Memorial Causeway drawbridge is to the right, c. 1960. (Courtesy of CPL.)

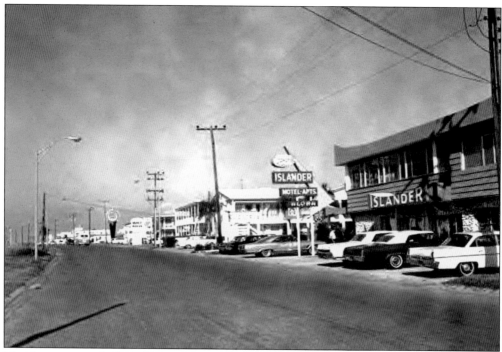

Motels are pictured along Clearwater Beach in 1964. Businesses along this strip are dependent on good weather and tourism for their economic success. (Courtesy of FSA.)

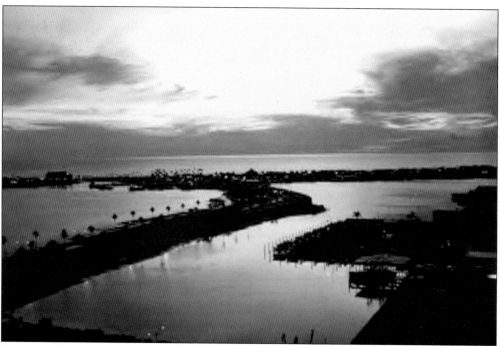

A breathtaking sunset of the bay is captured from the Horizon House and Island Estates in 1966. (Courtesy of FSA.)

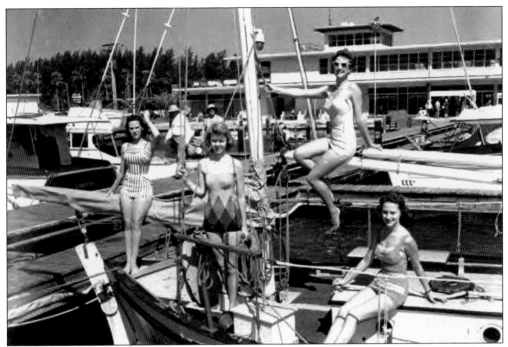

Beauty contestants pose on a boat during the Sun in the Fun Festival in 1956. Pictured from left to right are Jean Clark, Queen Jil Kirk (Miss Clearwater), Pat Smith, and Pat McNaughton. (Courtesy of FSA.)

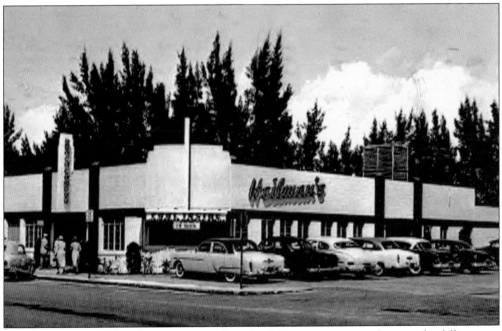

Heilman's Beachcomber dining room and cocktail lounge was a popular spot for folks to get together in 1954. (Courtesy of FSA.)

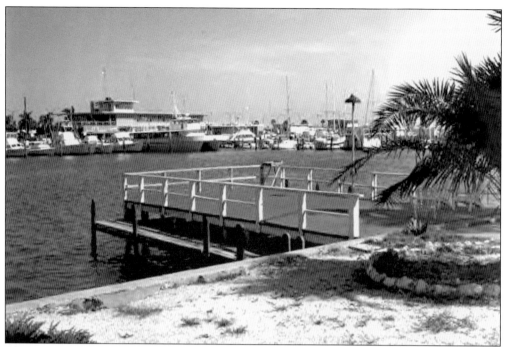

Clearwater Marina and Yacht Basinis seen in 1973 with several different-sized boats moored at its docks. (Courtesy of FSA.)

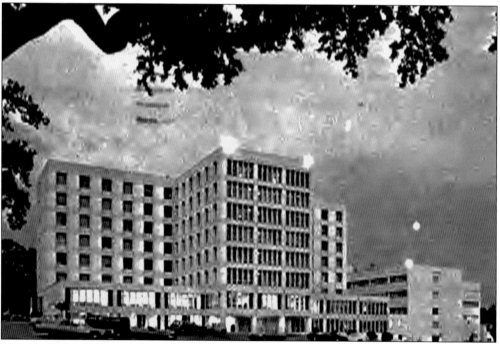

Morton F. Plant Hospital, located at 323 Jeffords Street, was founded in 1916. At the time of this photograph, in the 1970s, it had a 511-bed capacity and was being renovated to increase the beds to 750 for $10,000,000. (Courtesy of FSA.)

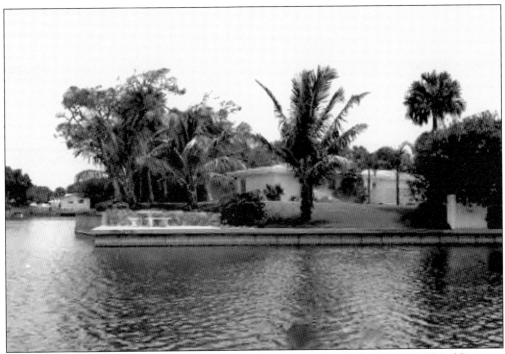

This nicely landscaped home is positioned along the banks of the bay in 1974. (Courtesy of FSA.)

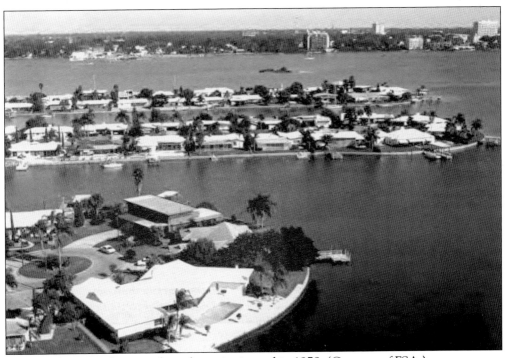

A Clearwater waterfront residential area is pictured in 1978. (Courtesy of FSA.)

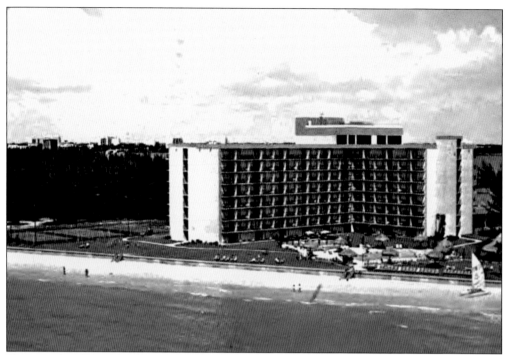

Sheraton Sand Key Hotel on Sand Key Isleis seen in the 1970s. (Courtesy of FSA.)

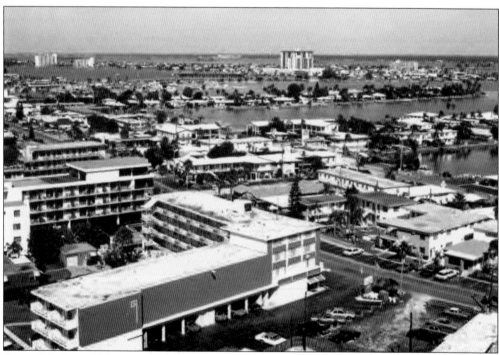

An aerial view of Clearwater in 1979 shows it as a progressive modern city. The photographer was Karl E. Holland. (Courtesy of FSA.)